SUSSEX RAILWAY STATIONS

THROUGH TIME

Douglas d'Enno

AMBERLEY

First published 2016

Amberley Publishing
The Hill, Stroud, Gloucestershire, GL5 4EP
www.amberley-books.com

Copyright © Douglas d'Enno, 2016

The right of Douglas d'Enno to be identified as the
Author of this work has been asserted in accordance with
the Copyrights, Designs and Patents Act 1988.

ISBN 978 1 4456 4876 7 (print)
ISBN 978 1 4456 4877 4 (ebook)

British Library Cataloguing in Publication Data.
A catalogue record for this book is available from the
British Library.

Typesetting by Amberley Publishing.
Printed in Great Britain.

Contents

Introduction

The purpose of writing this book is to provide a permanent comparative record of the many and varied stations, whether lost or operational, in the county of Sussex.

It is the first to focus, in colour, on juxtaposing early and present-day images of stations in this region and is intended not only for lovers of railways but also for those with an interest in architecture, restoration, heritage, social change and the development of towns and villages in the county. What emerges from these pages is that, while many stations have been lost forever, a fair number are living on in preservation (on occasion even sharing an operational main-line station, such as at Eridge), or as tastefully restored private residences and as commercial premises (such as at Heathfield).

The book is also timely, since an update is long overdue of a range of important volumes with a significant station content, which were frequently consulted as reference sources during the writing of this book. Examples are the excellent series by Vic Mitchell and Keith Smith (mostly published in the 1980s) and the informative 'Past and Present' books, largely authored by Terry Gough (which appeared in the 1990s and early 2000s).

Douglas d'Enno
Saltdean, May 2016

Acknowledgements

The early pictorial material in this book has, to a large extent, been kindly made available by Laurie Marshall of Hove from his substantial collection of specialist postcards depicting Sussex stations, especially those of the LBSCR. The remainder are from the author's own collection. Let us remember here the numerous publishers of picture postcards from times gone by, without whose work this book would not have been possible.

The author, when on his travels visiting every station described in this book, almost invariably met with willing assistance from local experts and, in several cases, occupiers (residential and commercial) of restored station buildings. I am additionally grateful to, among others, the Bluebell Railway Plc, Hartfield History Group, Hastings Reference Library, Henfield Museum, Hove Library, Messrs Lambert & Foster (Mayfield), Littlehampton Museum, Newhaven Local & Maritime Museum and to my friend and neighbour, Chris Wrapson, who kindly loaned me several important books

'Dumpman' has produced a wide selection of DVDs, whose many titles include useful explorations of the trackbeds of some of the disused railways featured in this book. Email: dumpman1@hotmail.co.uk; Website: www.dumpman.co.uk.

I also thank Neil White of Restorapic (Email: contact@restorapic.com; Website: www.restorapic.com) for his skilful and prompt enhancement of a considerable number of the early images that appear on these pages.

I finally acknowledge with thanks permission from the History Press to reproduce, on page 96, the railway map published in Phillimore & Co.'s *An Historical Atlas of Sussex* (1999).

Lost Mainline Stations

West Sussex

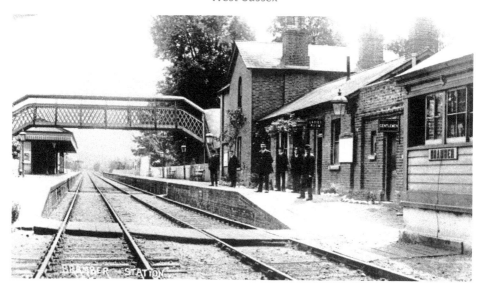

Bramber

This startling comparison reveals the extent of change more than almost any other location in the county. Today's view was photographed on 17 October 2015, looking south-east from the roundabout on the A283, or Steyning bypass. The road opened in 1981 to avoid the congested centres of Steyning, Bramber and Upper Beeding, and runs for much of its length along the LBSCR's old Shoreham–Horsham line of 1861, whose single track was doubled in 1880. It was never electrified. The roundabout is close to the site of the roadbridge formerly at the north end of the station, seen above in around 1910. It was the only station on the Steyning Line (also known as the Adur Valley Line) to be electrically lit and was the first to be reached from Shoreham-by-Sea on the 20-mile route. The line closed on 7 March 1966, courtesy of Dr Beeching, and now forms part of the Downs Link footpath and bridleway.

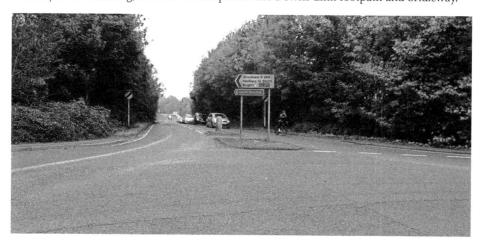

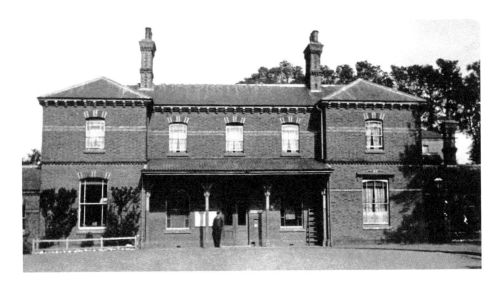

Steyning

Less than a mile north of Bramber is Steyning, whose station was the most important on the line. The early image shows its position at the end of Station Road, with Southdown Terrace on the right. Facing us instead today is the side of 2 Old Market Square, a semi-detached property built in around 1985. The goods shed once stood nearby. The square was an area that was a hive of activity for over 100 years, especially on Wednesdays when the cattle market was held, and contains the only surviving building hereabouts associated with the railway: a warehouse formerly used as auction premises and converted into dwellings in 1987.

To mark the centenary of the Brighton–Horsham route, a celebration was held at Steyning station on 7 October 1961. Five years later the station was gone. The trackbed has become the fast Steyning bypass, from which the station's east retaining wall and the former warehouse remain visible.

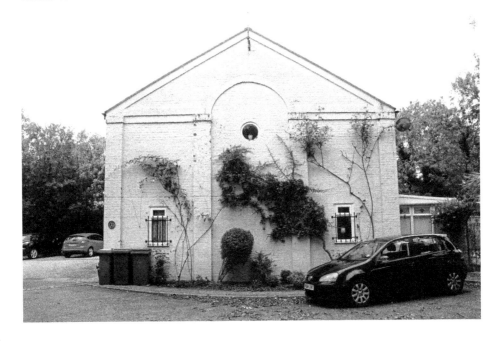

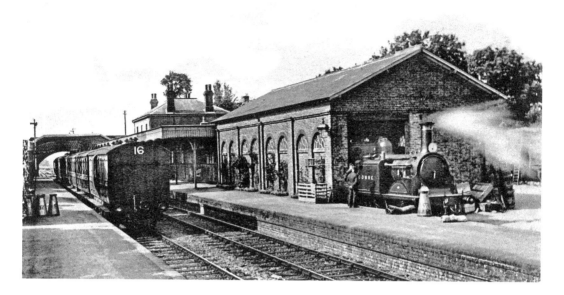

Henfield

This classic vintage view of Henfield Station (1861–1966), 4.5 miles north of Steyning station shows Stroudley's D1 Class No. 223 *Balcombe* partly within the goods shed early last century. In the background, beyond the stylish canopy, are the station house, the footbridge and, behind that, the road bridge; its position was beyond the houses at the far end of the author's recent picture of part of 'Beechings', a development of the station site dating from the early 1970s. The goods shed would have occupied most of this road's width, with its southern end halfway along No. 26 (the house on the right with the car outside). The actual track at this point would have run through the front gardens of the houses on the left, namely Nos 12 and 13.

A fine, detailed oo-scale model of Henfield Station and its surroundings, built by Bob Munnery (1937–2002), is on display at Henfield Museum.

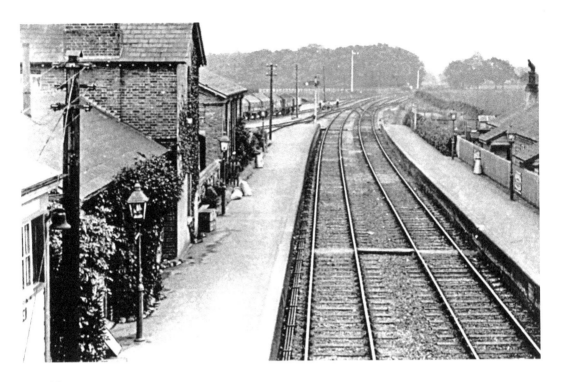

Partridge Green

It is difficult to get an exact match of views here, especially since the early picture would have been taken from the station footbridge, which stood a little way in front of the road bridge on which we are standing in the photograph below. Our view of the Down platform (above) shows part of the signal box (redundant in later years through signalling being controlled at Steyning) and the goods shed beyond the station house (a comparative picture in a 1993 railway book shows the foundations of the goods shed still in place on overgrown land as yet undeveloped). The lines to the goods yard can be seen veering off to our left in the distance, while the row of cottages beside the Up platform is thought to have been erected for the line's construction workers.

Today's view from the bridge carrying the B2135 (Steyning–Horsham) road reveals how the station site has been transformed by the development of Meyers Wood.

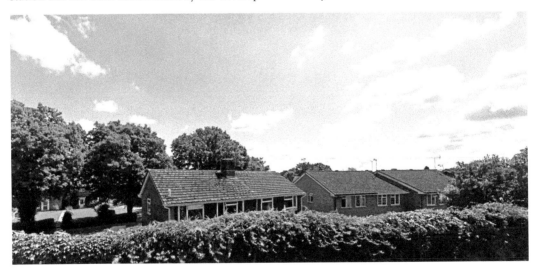

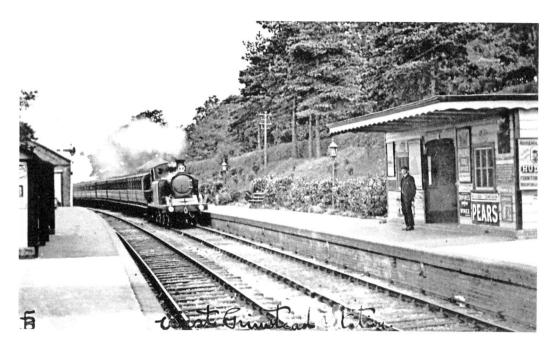

West Grinstead

This station site, 2.25 miles north of Partridge Green's, is a splendid relic – with added memorabilia. Not only have the platforms and trackbed survived (the latter as part of the Downs Link footpath) but, as a bonus, local efforts have been made to bring the past back to life, such as in the installation by the parish council of an old railway signal and the erection of a replica station sign. A railway coach (British Railways Mark 1) has also been placed as a Downs Link information centre on rails in the former goods yard, where there was once a cattle-loading bay and facilities for handling horse boxes (horses accounted for much traffic). The station house survives as a dwelling on the Cowfold Road above the cutting.

Our comparative pictures show an E4 tank racing south pre-1914 (above) and the trackbed on 20 July 2015, complete with resident tree (below).

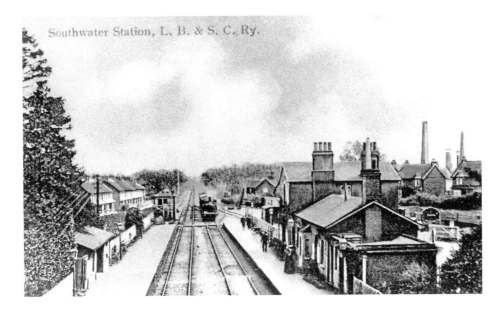

Southwater Station, L. B. & S. C. Ry.

Southwater

There are few greater contrasts between 'then' and 'now' than the one to be seen in Southwater, the next station north of West Grinstead. We know the early picture, facing south, was taken from the road bridge since, uniquely for the line, the station had no footbridge, only a boarded crossing. The goods siding veered off to our right, as did a dedicated siding operated by the nearby important brickworks whose chimneys can be clearly seen. It closed in 1982. The station buildings, including the tiny goods shed, were demolished after closure in 1966, although the house survived for some years as a residence.

The entire station site (save for some lengths of platform) was entirely redeveloped in 2006 with the creation of Lintot Square, photographed here (see below) on 20 July 2015. In the distance is a war memorial, erected as recently as 2008. As elsewhere, the trackbed is now the Downs Link footpath/bridleway.

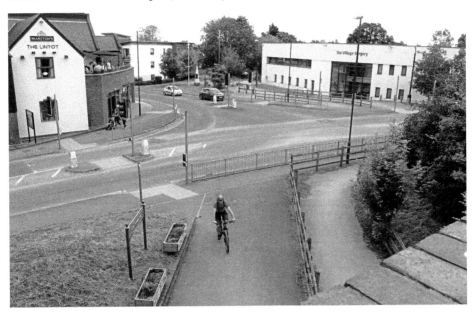

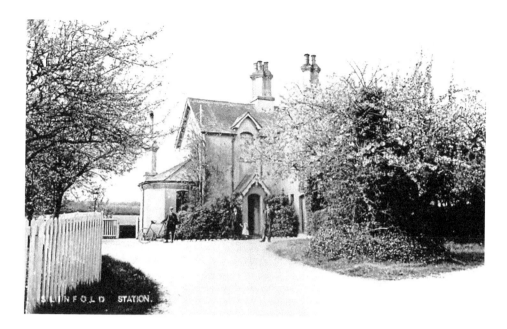

Slinfold

Readers doubtless imagine our next port of call, if on the line, to be Christ's Hospital. However, as an operational main-line station, that must be excluded from this section. Several miles to the north-west, however, once stood the delightful country station of Slinfold. It was one of several constituting the single-track Cranleigh line (1865–1965) linking Horsham and Guildford. A Beeching casualty that closed just a few months short of its centenary, it had a small goods yard, three private sidings serving a brickworks and a timber yard. The well-built stationmaster's house, near which stand two LBSCR houses, survived as a private residence for several decades.

The trackbed forms part of the Downs Link footpath/bridleway and the sidings area once adjacent to the station lives on as the park of a caravan club. The office, seen below on 20 July 2015, proudly displays memorabilia – including a milk churn – of the station on whose site it stands.

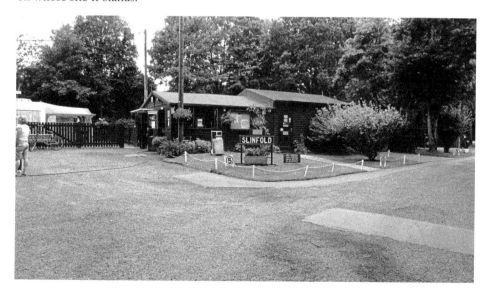

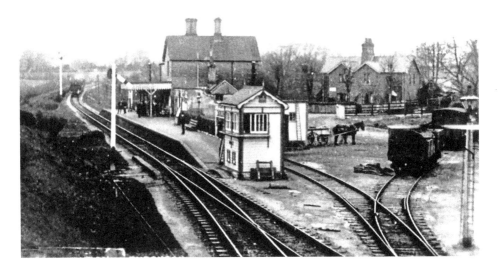

Rudgwick

This is the next stop on the route towards Guildford, and the last within Sussex on the Horsham–Guildford route. Initially, trains did not stop, due to the steep gradient. The solution adopted was to construct a girder bridge above the original brick arch over the River Arun.

The station, seen here (above) from a road bridge on what is now the B2128, had a single platform with a shelter, a signal box and a small goods yard (lifted in the autumn of 1963) centred on a wagon turntable, the last on the line. The stationmaster's house, boasting a chimney of extraordinary height, was demolished following closure in 1965; Rudgwick Medical Centre now occupies its site in a close aptly named The Sidings. An adjacent block of flats also overlooks the Downs Link footpath/bridleway. The Victorian house on the right in the photograph above has not only survived but boasts an extension named Sidings Place.

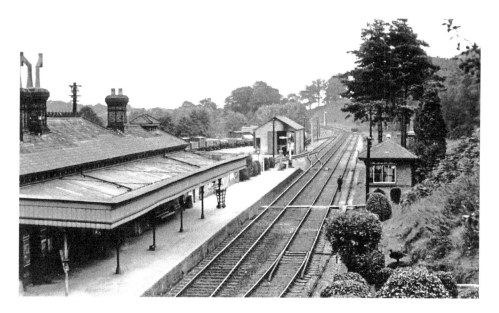

Petworth

This station was located on the former LBSCR single-track Pulborough (Hardham Junction) branch line to Midhurst – one of three to serve that market town. Petworth opened on 10 October 1859 and was rebuilt in around 1890. With its sizeable goods yard, it enjoyed considerable traffic in freight, a service that continued until 20 May 1966, eleven years after the station closed to passengers due to low demand (unsurprisingly, since the station was over two miles south of the town).

After closure, there was a period of abandonment, then a local coal merchant took over the site. Use as an antique furniture and craft business (whose output included small wooden elephants) followed, this being in turn succeeded by residential occupation. For some years, the elegantly restored building and grounds have been run as 'The Old Railway Station Hotel', with novel accommodation in the grounds also available in the form of four retired Pullman cars, which were previously at Marazion, Cornwall.

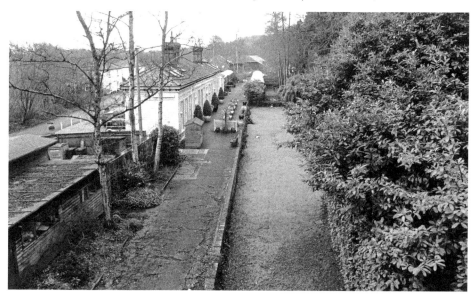

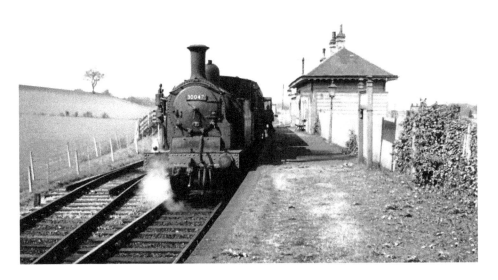

Selham

It is 19 April 1954 and M7 0-4-4T No. 30047 propels a Pulborough–Midhurst push-pull train into the station, located just over 3 miles east of that town. On the left is a sparsely used cattle dock, accessed by a sloping road. The nearby pub, The Three Moles (originally The Railway Hotel), and the hamlet would hardly have provided much business for this isolated wooden station, especially since a local bus service was introduced in 1945. It closed to passengers in 1955, although goods, including coal, livestock, milk and even chestnut fencing, were handled until May 1963. The line remained open for another year, serving Midhurst. It had opened in 1866 (seven years later than that to Petworth from the east), although the station did not open until six years later, when the hotel also opened.

The station building has been a private residence for decades. It was skilfully doubled in size and form in 2013 by the present occupants and is on the market at the time of writing.

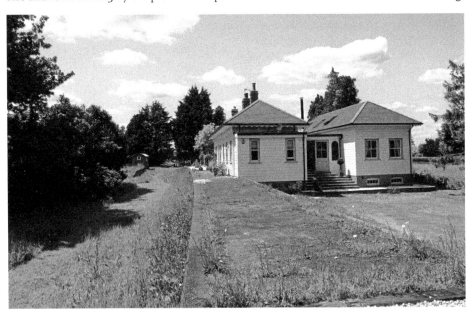

Midhurst

There were two stations at Midhurst: the LSWR's from Petersfield of 1864 and the LBSCR's from Pulborough of 1866. This was re-sited in 1881, its house being built to an attractive design by railway architect T. H. Myres (see Cocking station).

There was no through running until 1925, when the LSWR station (which has survived as offices) closed. Its rival, by then operated by the Southern Railway, thereupon became the town's station. Previously, a long and inconvenient journey on foot had been necessary for any passengers transferring between the two. Midhurst station closed to passengers on 5 February 1955, but goods traffic between Midhurst and Pulborough continued until 16 October 1965.

Our first view, eastward, depicts the station, wet and deserted, on 1 September 1951. The startling comparative photograph below was taken on 5 March 2016 from The Fairway, by its junction with Bourneway.

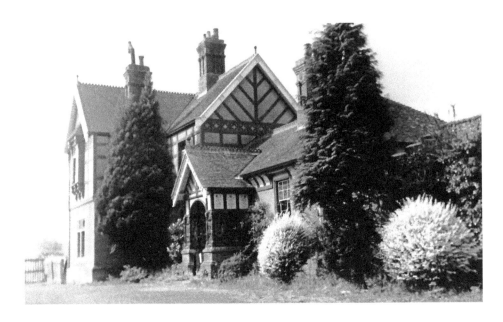

Cocking

The house at Cocking station, between Chichester and Midhurst, was built in 1880 to the design of Thomas H. Myres (1842–1926) in the Old English style. The architect designed a total of eighteen stations and ancillary buildings on other lines for the LBSCR in the 1880s, including those on the new lines from Hailsham to Eridge (opened 1880), Lewes to East Grinstead (opened 1882) and Haywards Heath to Horsted Keynes (opened 1883).

Cocking station, serving a small village of under 500 people, opened in the year following the building of the house. Lacking the anticipated patronage, it closed to passengers on 6 July 1935, although a goods service continued. That between Cocking and Midhurst was ended by the collapse of a culvert near Midhurst in November 1951, whereupon Cocking became the terminus of the line from Chichester until 28 August 1953, when it was closed completely. The station house was sensitively and substantially extended by the present occupants twenty-five to thirty years ago, as the picture below, taken on 24 May 2016, clearly shows.

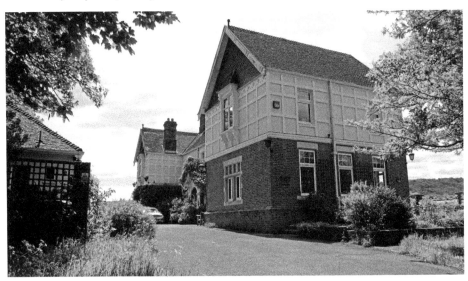

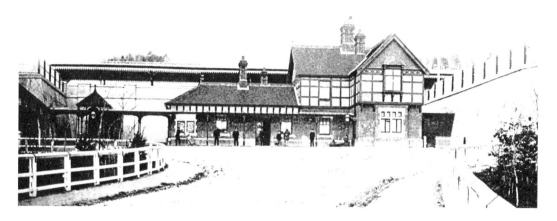

Singleton

The next station on our way south to Chichester was imposing, yet far too lavish. It was opened in July 1881 with an eye to the lucrative traffic generated by Goodwood Racecourse. Two long, canopied island platforms provided four platform faces while the 0.75 miles of sidings could hold fourteen trains on race days. There were two signal boxes, an ornate goods shed, a magnificent refreshment room, complete with marble counter, and one of the largest gentlemen's toilet blocks ever built for a country station. Yet outside of the race days, there was little activity. Competition from buses led to closure to passengers in 1935, although a freight service continued until 1953.

The elegant house, built in 1880, survives as a private residence owned by West Dean Estate. From 1972 to 2011, it served as the reception centre of the Chilsdown winery, whose vineyard was established on the hillside west of the platforms.

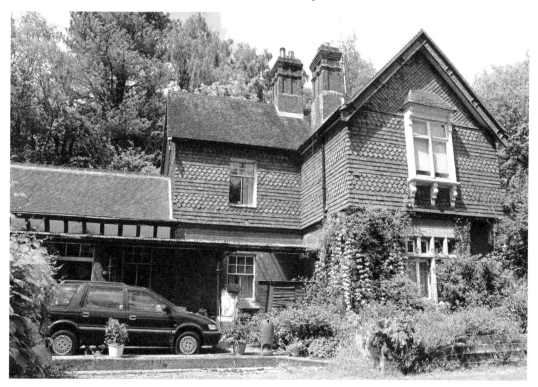

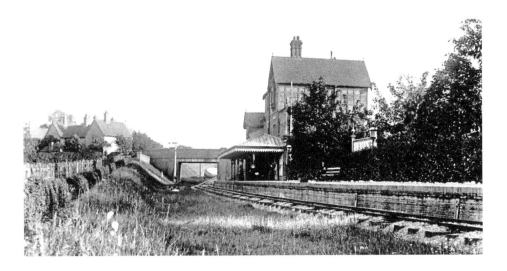

Lavant

The three-storey station house at Lavant, a mirror image of that at Newick and Chailey (see page 33), with the platform at basement level, was another Myres creation. The station had something of a charmed life for, when passenger services were withdrawn in 1935, freight, including sugar beet, remained. Despite general goods services being withdrawn on 3 August 1968 and sugar-beet traffic continuing only until 1 January 1970, the line was cut back south of the closed station to serve a new Parker Concrete Group gravel pit from 1972, an operation that lasted until 1991, when the pit itself closed. The tracks were lifted in 1993, although the trackbed between Chichester and West Dean survives as part of the Centurion Way Railway Path.

The station canopy was removed for reuse at Horsted Keynes on the Bluebell Railway. In Warbleheath Close (see below) the rear of the station house contains several flats, while at the front, in parallel Churchmead Close, the building is shared by three residences, Nos 59–61. A plaque on No. 60 records 26 January 1993 as the official opening date of the station house redevelopment.

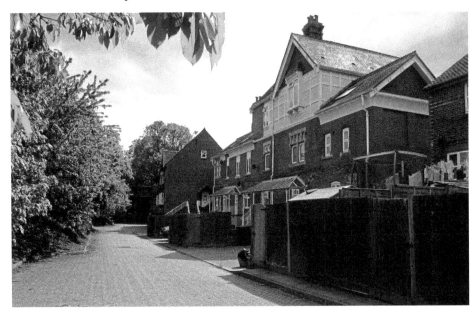

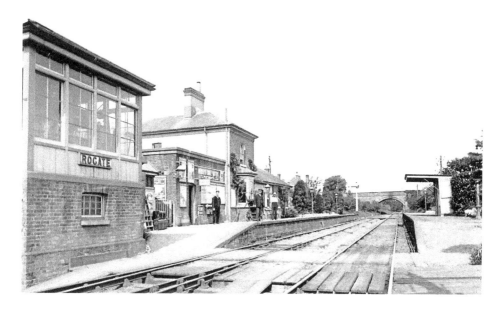

Rogate

The station (variously named 'Rogate', 'Rogate for Harting' and 'Rogate and Harting' at different times) was inconveniently located in Nyewood, well over a mile from either of those villages. Opened on 1 September 1864, the station originally featured two platforms controlled by a fully operational signal box although, from 1932, this was only used for handling goods yard trains. The line closed to all traffic on 5 February 1955. That was not the end for the buildings, however, which survived for commercial use. Interestingly, noted railway author Vic Mitchell converted them into an acrylic castings factory for Mitchell Mouldings Ltd in 1968. They now serve – and have done for many years – as the offices of prominent building firm Richardsons (Nyewood) Ltd, established in 1965. Beyond the roadbridge, just about visible in the 3 March 2016 photograph below, was a siding serving the Nyewood brickworks. There was a sawmill nearby.

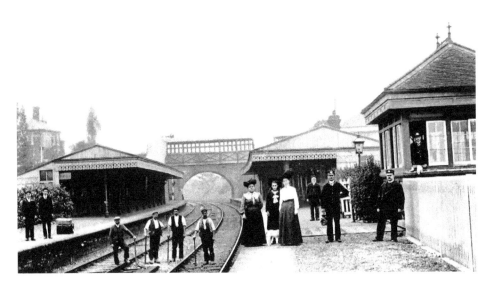

Ardingly

The attractive, neo-Queen Anne style station house at Ardingly is out of sight up at road level, and currently serves as the offices of Hanson Asphalt Ardingly depot. Using its own line via Copyhold Junction, north of Haywards Heath, the company runs three trains a week on a line behind the photographer, usually bringing in stone from Somerset and, very occasionally, granite from Wales. Mountains of materials are stored here. The picture below, taken on 4 October 2015, features a surviving fragment of the Down platform. In stark contrast, the Edwardian photograph above shows stationmaster George Fossey standing by the signal box in company with railway staff and three ladies.

Opened on 3 September 1883 by the LBSCR on the 4.5-mile line linking Horsted Keynes and Haywards Heath, the station closed eighty years later. In its heyday, it was busiest when serving the needs of nearby Ardingly College.

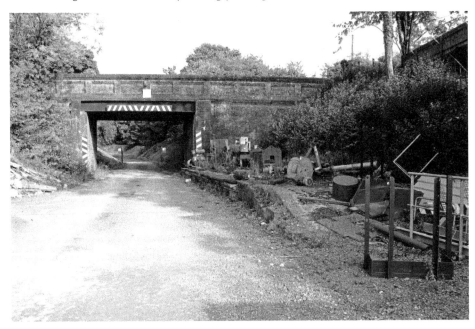

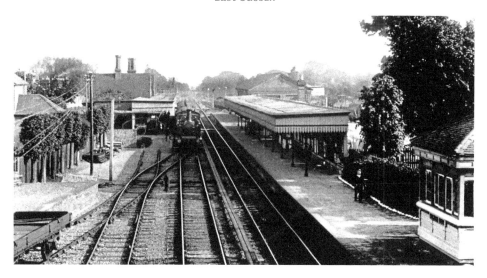

Hailsham

This station, and the five on the following pages, stood on the 'Cuckoo Line' (a name derived from the cuckoo released each spring at Heathfield's fair), which linked Polegate and Eridge from 1880 to 1968. Hailsham lost its northward passenger service in 1965 and its southward in 1968. Originally built in 1849 by the LBSCR, it was a terminus station serving both passengers and livestock for the nearby market, and remained such until 1880 when it was connected with Eridge by a single line. That line has become the Cuckoo Trail public footpath, while a whole area of the station site is now a public car park. On the left of both our views is the hipped-roof single-storey extension of Station House, only part of which can be seen in the author's photograph of 1 November 2015. Opposite the house, in Station Road, stood – and stands – the Railway Tavern.

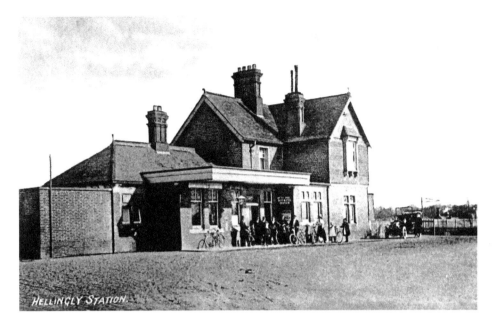

Hellingly

As in the case of the other four attractive intermediate stations from here northward to Eridge, the architect was Thomas H. Myres and the builder was James Longley & Co. of Crawley. The house at Hellingly, privately occupied by the same owner for some thirty years now, is well-preserved and the platform canopies have been retained. The adjacent trackbed has become part of the Cuckoo Trail long-distance footpath.

The nearby Hellingly Hospital Railway operated a 1.25-mile tramcar service for passengers from here beginning in 1903, following its electrification in the previous year, and continuing until 1931. The line was thereafter used for freight, mainly coal, until 1959, when it closed due to the hospital converting its coal boilers to oil. The majority of the buildings closed in 1994. The three-bedroom station house, as at 1 November 2015, is seen below.

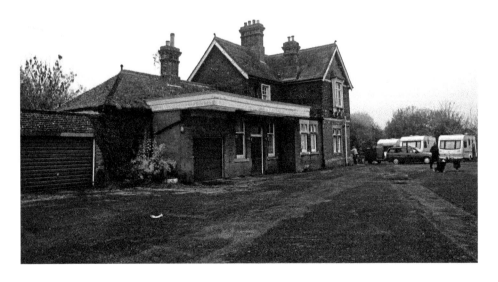

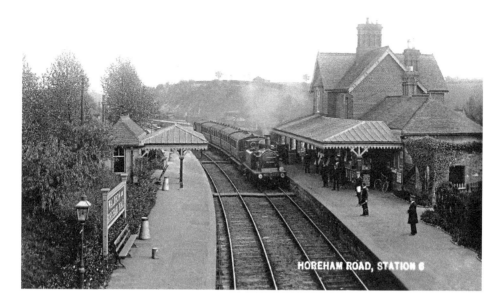

HOREHAM ROAD, STATION

Horam

Next up the line is Horam, where northbound D1 tank No. 273, formerly *Dornden*, arrives for her passengers. She entered service in 1880, the same year as the station opened. Horam served its namesake village, nearby Horeham Manor and Waldron, 2.5 miles away, and had no fewer than five names during its life: Horeham Road for Waldron (originally), Horeham Road and Waldron (from 1 January 1890), Waldron and Horeham Road (from 1 April 1900), Waldron and Horam (from 1 January 1935), and finally Horam (from 21 September 1953). Goods traffic, generated largely by Express Dairies for which Horam was the main depot, continued until complete closure in 1968.

Much of the site was cleared for housing in the early 1990s, yet a third or so of the southbound platform, a short length of the northbound platform and its name board, a concrete lamp post and a totem sign, survive alongside the Cuckoo Trail as evident below on 23 November 2015.

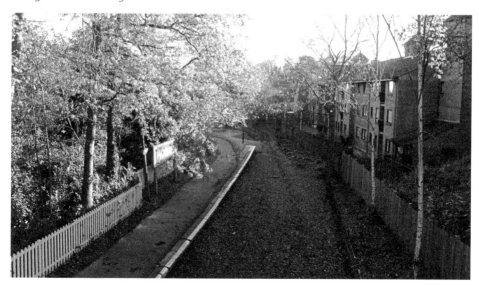

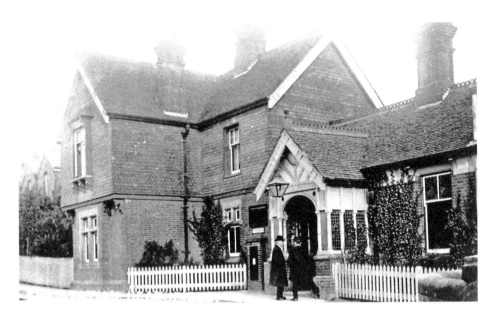

Heathfield

The station site was deep below and just beyond the roadbridge, part of whose wall is visible at the bottom right of these pictures. It was accessed by a fully glazed footbridge, most of it removed by 1939. The station building is currently (and has been for thirteen years) the premises of Steamer Trading Cookshop and Café. Beside the house is a small property calling itself 'The Station House' and further up Station Approach (railway property until the end of 1902) stand the Railway Cottages (two pairs), built in 1897 for railway staff.

Natural gas was discovered here in the previous year during test-boring to find a water source and was used both for station lighting and, by means of a gas-powered engine, for pumping water. Subsequent commercial exploitation was, however, unsuccessful. By 1963 the supply was found to have diminished significantly and the bore was sealed.

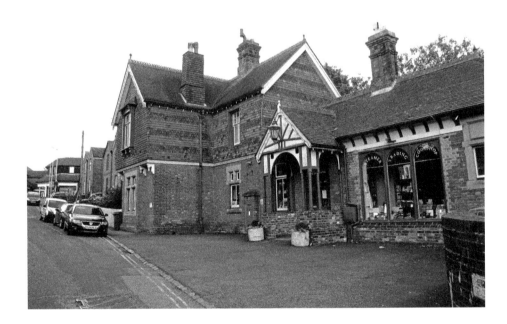

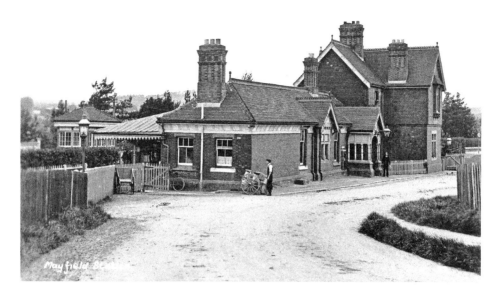

Mayfield

The author remembers using this station in the late 1950s to catch his train home to Brighton for the holidays when attending a large boarding school situated outside the village. Today the station building, its platforms removed, overlooks the fast Mayfield bypass (A267), which has replaced the trackbed. It is the only station along the Cuckoo Line to retain its entrance porch in near-original condition (complete with the stained glass mostly intact). The ticket office and associated rooms remain unconverted. The grounds extend over approximately 0.3 of an acre and contain mature plants and shrubs but require clearance in places. Although in residential use for many years, the building has deteriorated and needs substantial refurbishment. This was reflected in the asking price of £475,000 in the autumn of 2015 when it was offered for sale by contractual tender.

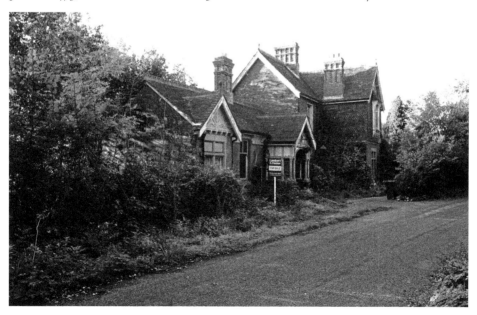

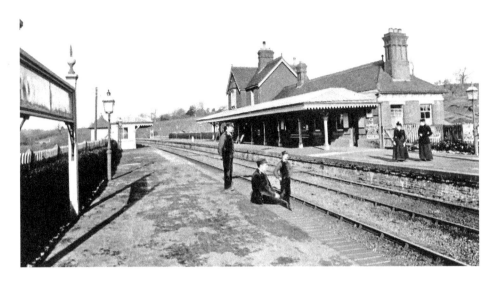

Rotherfield and Mark Cross

On this visit to a Cuckoo Line station (complete with its Myres house), the difference between our images is spectacular. The photo taken on 3 October 2015 shows, uniquely in Sussex, a section of trackbed in use as a swimming pool. An extension has been built over the former platform. Opposite, the retained platform canopy now forms the roof of a sun lounge.

Next door, behind the photographer, the long, low booking office has survived relatively intact as a separate residence, complete with some small stained-glass windows. Above an extension to it, the name sign 'Station House' has been attached to the balcony railings; the main house, pictured here, whose occupant has been in residence since 1996, bears the name 'Towne Place'.

Goods facilities were withdrawn from the station on 8 October 1962 and housing now occupies the site of the extensive yard and shed.

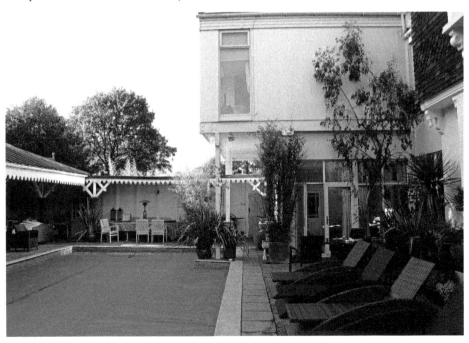

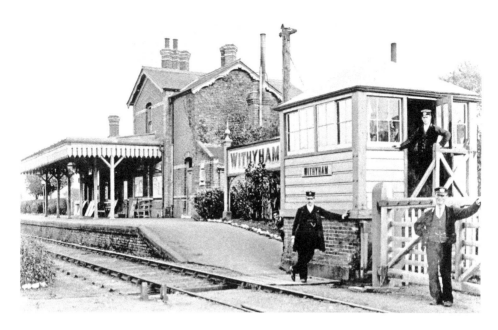

Withyham

Although this quiet station on the Three Bridges–Tunbridge Wells Central line fell victim to Beeching in 1967 after an innings of 101 years, the fine station house, now whitewashed and well-kept, has survived as 'Old Withyham Station'. The present owner has lived here for around twenty years (as at 27 September 2015, when the 'now' picture was taken). The single platform remains visible in places along the Forest Way Country Park cyclepath/ footpath, which occupies the trackbed. The signal box that controlled the gates at the level crossing at the western end of the station (where the walkers are) is now preserved at Sheffield Park station on the Bluebell Railway. There was a goods yard to the east of the station on the south side.

The photo views look towards Ashurst Junction and Tunbridge Wells.

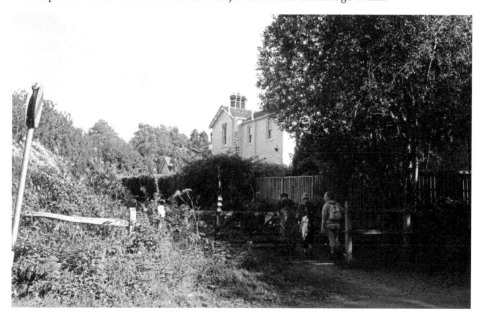

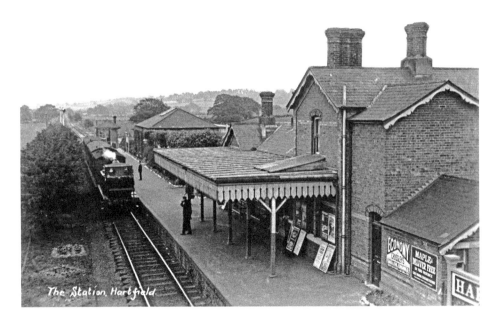

The Station, Hartfield

Hartfield

The next stop westward to East Grinstead after leaving Withyham is Hartfield, which is another delightful survivor with the exception of the signal box. The main station house has been converted into a residence and extended, with a garden created by raising the trackbed to platform level. This is screened off by a hedge from the adjacent Forest Way footpath/cyclepath/bridleway linking Groombridge to East Grinstead, although the author's photo taken on 27 September 2015 from the fine block stone roadbridge shows the layout.

Next to the house, the old railway offices, which proudly display two giant signs at their entrance: 'Hartfield' and 'Station', have become Hartfield Pre-School Playschool, which celebrated its golden jubilee in 2015.

The large goods shed nearby has been sympathetically converted into a parish office and meeting room, with two rented flats above. Goods Yard House was opened by the Earl of Lytton on 23 January 2012.

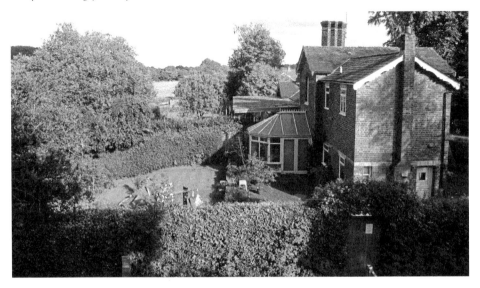

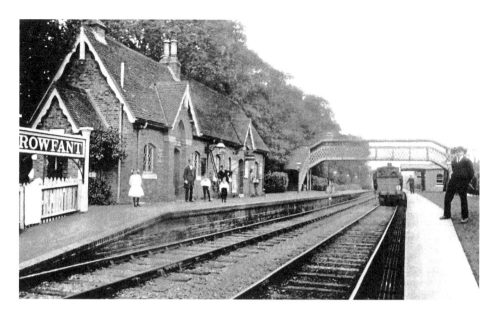

Rowfant

A charming country station, delightful to look at but, together with Kingscote, the poorest revenue-earner in the county. Opened with one platform by the East Grinstead Railway on 9 July 1855, it served no village but had been built largely for the benefit of wealthy American fur trader, Curtis Miranda Lampson of Rowfant House, who sold his land to the railway cheaply on the condition that a station was built there. Enlargement came in 1900–1901 with the acquisition of a loop, a new 500-foot Up platform and a footbridge. It closed on 2 January 1967.

The premises are now occupied by Colas, manufacturers of roadmaking materials – thanks to them for access. Part of the eastbound platform and the main station building, boarded up, have thankfully survived, as seen below on 4 October 2015. The stationmaster's house lives on nearby as a private residence. The line of the railway is followed on its north side by Worth Way, a popular public footpath and bridleway.

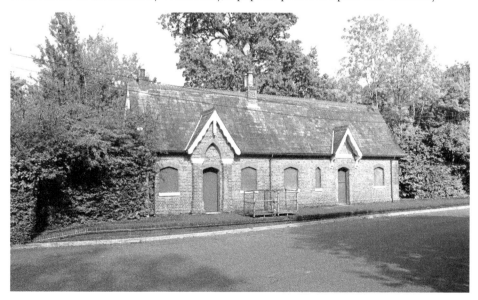

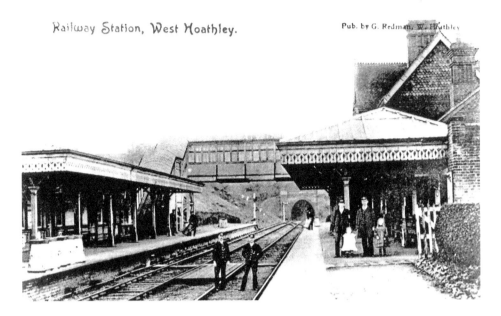

Railway Station, West Hoathley.

Pub. by G. Redman, W. Hoathley

West Hoathly

The station was actually situated in the village of Sharpthorne, half a mile from West Hoathly village. It stood immediately north of the 731-yard Sharpthorne Tunnel, the longest in UK preservation. The early picture above dates from around 1905 and shows not only the station staff and two small family members but also, on the Up platform, part of the fine 'Old English' style house that was sadly demolished in late 1967, plus the 50-foot glazed footbridge. A cattle dock was located on the far side of the hedge.

The station originally closed on 30 May 1955 but was reopened between 7 August 1956 and 17 March 1958, due to legal objections. The site was bought by the Bluebell Railway in 1974. Its Maunsell Loco No. 847 is seen below on the 1.30 Sheffield Park–East Grinstead service via Horsted Keynes and Kingscote on 4 October 2015.

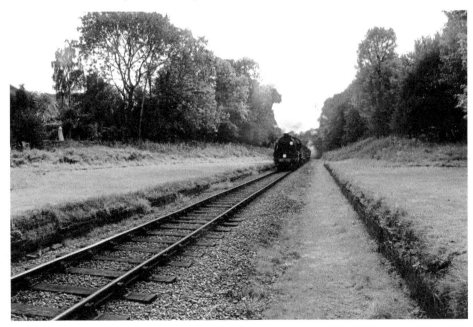

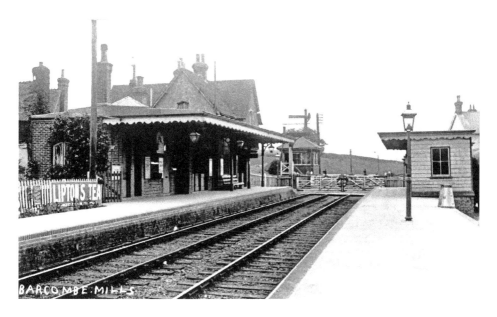

Barcombe Mills

Located near the River Ouse, this station was always popular with anglers – the author was one himself and remembers using it in his youth. Operational from 1858 to 1969, it was the first stop after Lewes on the south section of the Wealden Line, a partly abandoned double-track line linking Lewes with Tunbridge Wells over a distance of 25.25 miles. It stood nearly a mile from the village, opening as 'Barcombe', but was in 1885 renamed 'Barcombe Mills' to avoid confusion with Barcombe station on the Lewes–East Grinstead line. In 1985, it was purchased by the current resident, Allan Slater, who painstakingly set about restoring it, converting the stationmaster's small house into a four-bedroom family home. For a time, he ran a tearoom/restaurant called 'Wheeltappers' using the converted ticket office and ladies' waiting room and, in 2003, built two chalet-style holiday cottages where the wooden Down platform waiting room once stood.

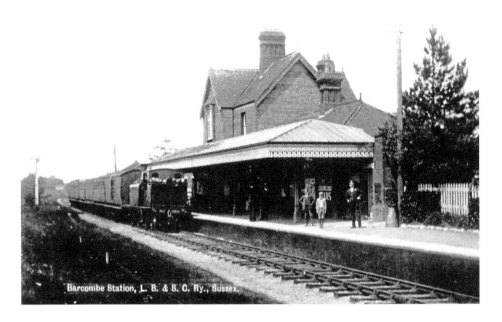

Barcombe Station, L. B. & S. C. Ry., Sussex.

Barcombe

In a rural idyll, Class D3 0-4-4 tank No. 386 stands with her train at Barcombe station. Originally 'New Barcombe' when opened in 1882, its name was changed to plain 'Barcombe' on 1 January 1885. Unusual in having only one platform, it was the smallest station on the East Grinstead–Lewes route but proved to be one of the busiest, with regular travellers bound for Lewes and Brighton.

Goods traffic, in the form of hay, straw and – importantly – milk, was also heavy. Goods sidings were installed in 1897 and a goods loop was laid in 1905. Although officially closed on 13 June 1955, the last train actually ran on 28 May 1955 because of a strike. The property, sympathetically restored and extended, has been occupied by the same resident and his family since 1990. He has filled in the trackbed to platform level, creating a large lawned area, beside which the trees he planted have matured to afford some seclusion.

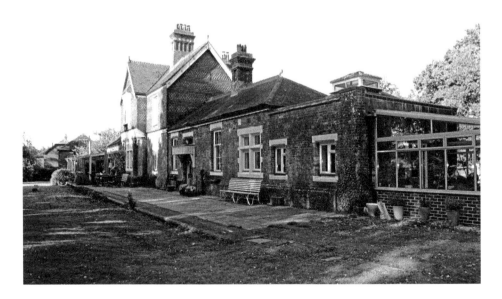

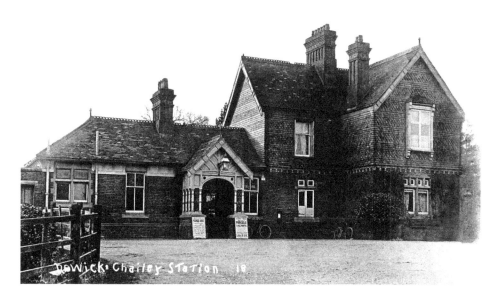

Newick and Chailey

The next station north of Barcombe was Newick and Chailey. Here the house, a typical design by Thomas H. Myres that was sadly demolished in the mid-1960s, appears virtually identical to its neighbour. Interestingly, 'reversing' the design from right to left gives us the front elevation of the station at Lavant (see page 18). Unlike at Barcombe, Newick had two platforms, connected by a covered footbridge. This was removed, together with the Up platform, when the complex was rationalised in the 1930s. Also, unlike at Barcombe, the line closed in 1958 following its forced reopening in 1956 due to a legal challenge. The track was removed in 1960 and the site of the platforms in a cutting was subsequently infilled and covered by housing. The bungalow depicted in the photograph below is in Lower Station Road (about halfway between Newick and North Chailey) and appears to be located on, or very near to, the site of the station building.

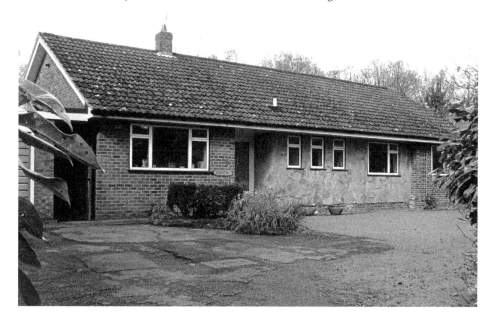

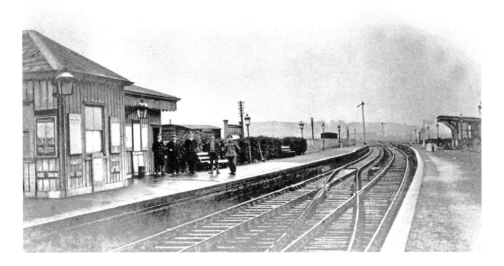

Bishopstone/Bishopstone Beach Halt

Turning to the coast, the lost hamlet of Tide Mills lay roughly 1.2 miles south-east of Newhaven and 2.5 miles north-west of Seaford and was near to both Bishopstone and East Blatchington. It was mainly to provide a rail service for the community's 100 or so workers that the LBSCR, on 1 June 1864, opened Bishopstone station on the Seaford branch line. A spur from the main line for goods traffic was created, which actually ran along the hamlet's main street. By 1940, however, the settlement had been cleared on sanitary and home defence grounds, while the station, for its part, had been replaced in the previous year by a new Bishopstone station (today's) about half a mile to the east. It had been renamed Bishopstone Beach Halt on reopening after a year-long closure. It closed for good on 1 January 1942. Our pictures show the station in what was probably the First World War period and on 20 September 2015, when the platforms could be clearly seen.

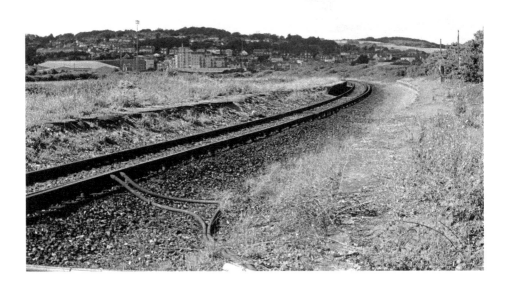

48074

Bexhill West

Some 17 miles east of Bishopstone as the crow flies stood the SECR station of Bexhill West (1902–64) where, from Platform 3, we see an unidentified SECR 'H' Class tank with her train in 1906. The station was the terminus of the 4.5-mile Bexhill West branch from Crowhurst Junction. Its name on opening was 'Bexhill' but in 1929 this was changed to 'Bexhill West' (the LBSCR's rival Bexhill station on the Hastings–Brighton line had opened more than fifty years earlier).

The handsome, but excessively lavish, station building in the background has fortunately survived; it is currently in use as an antiques centre, coffee lounge and 'The West Station' public house/restaurant. The trackbed and site of the platforms and engine shed are now occupied by the showroom and workshop of Bexhill Motors and its car park, within which a section of the once-lengthy canopy remains intact.

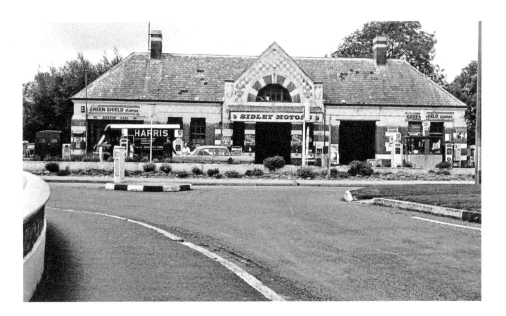

Sidley

The platforms of this intermediate station on the Bexhill West–Crowhurst branch (1902–1964) were sited in a deep cutting, while the eye-catching red brick and Bath stone station offices stood at street level. These were let in 1938 by the SR, which transferred the booking office to the waiting room on the Up platform. In 1939 the station building became a club, later converted to a garage. This was replaced in 1971 by the BP service station we see today.

The station complex included a twenty-lever signal box, a goods yard and sidings. The platforms and their buildings were demolished in 1967 (although the derelict goods shed was not until 2009), and the cutting was infilled to about platform level. The site was then used by a motorbike training centre, which closed in 2012. The new 3.5–mile Bexhill–Hastings link road (the 'Combe Valley Way'), which opened on 17 December 2015, now runs through the cutting.

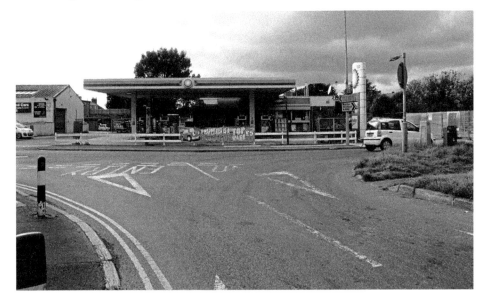

PART 2
Heritage Railways

The Bluebell Railway

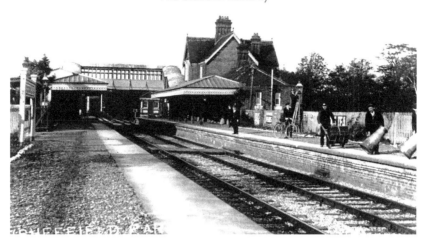

Sheffield Park

Originally named 'Fletching and Sheffield Park', this station is today the headquarters of the 11-mile-long The Bluebell Railway, the first preserved standard-gauge steam-operated passenger railway in the world to operate a public service. We know the old Lewes & East Grinstead Railway as the 'Bluebell Line', but formerly (certainly up to the 1950s) it was called the 'Bluebell and Primrose Line'. As we saw earlier, the line reclosed in 1958 following a period of three years and four months of operational reprieve. In 1960, a preservation group ran its first train and, eight years later, had raised enough funds to purchase both Sheffield Park and Horsted Keynes stations. A major objective was achieved on 23 March 2013 when the railway's new East Grinstead terminus was opened.

The early postcard (above), posted in July 1913, features Stationmaster George Reddish, second from the left, and his staff, while the 'now' photograph below depicts a newly arrived train on 26 September 2015.

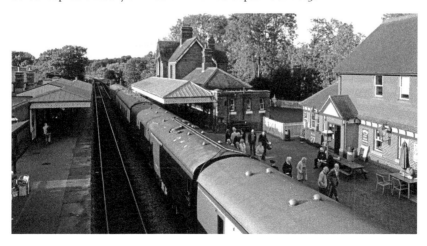

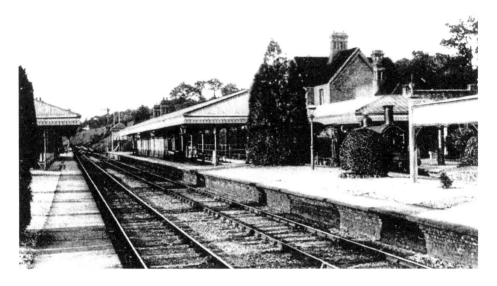

Horsted Keynes

The termination of services at the junction station of Horsted Keynes under BR came in 1963 – five years later than at Sheffield Park. Active in the meantime, the Bluebell Railway ran its first trains using the disused eastern side of the station on the last day of the season in that year.

Both stations opened in 1882 and the houses at both were to T. H. Myres' standard design. In the following year, the LBSCR built a line to connect Horsted Keynes with Haywards Heath with one intermediate station at Ardingly. Reopening this line is a medium- to long-term objective of the Bluebell, although a major obstacle is the current use of the Ardingly station site by an aggregates company (see page 20). Encouragingly, however, land has been set aside at Haywards Heath as a site for a station in the town.

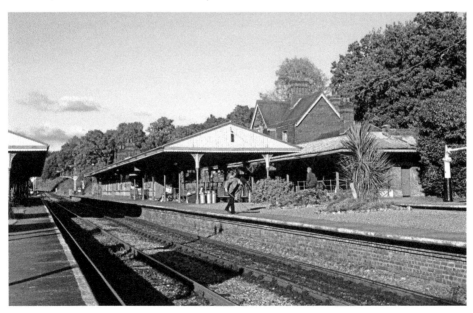

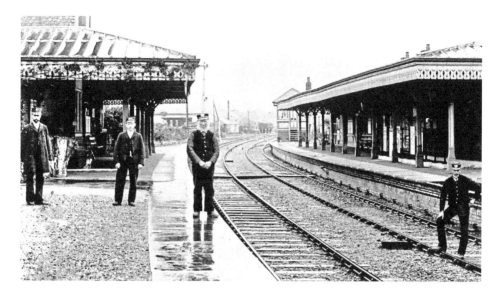

Kingscote

At the remotely sited LBSCR station at Kingscote of 1882 (above), we see the signalman on the right and, on the left, Stationmaster Thomas Ward, whose lovingly grown roses decorate the canopy behind him. In the far background is a large timber yard. The goods shed was moved to Horsted Keynes in 1910. A 50-foot glazed footbridge connected the platforms of the station, which closed on 29 May 1955. In the 1980s, most of the site was acquired by the Bluebell Railway Extension Company Ltd, which reopened the station on 23 April 1994. It served as the railway's northern terminus until 2013, when the extension to East Grinstead was opened. The restored three-bedroom station house, to Myres' design, has been rented by the same family for the last ten years at the time of writing.

On 6 March 2016, Maunsell's Q Class loco No. 30541 arrives at Platform 2 tender-first with the 14.28 service from Sheffield Park to East Grinstead in the photograph below.

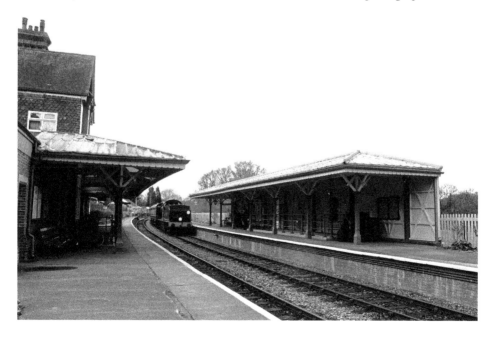

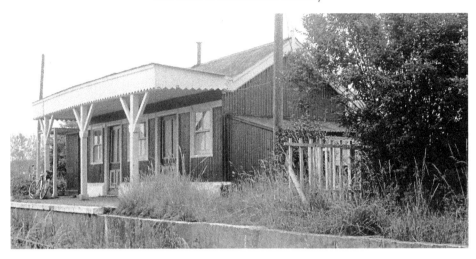

Bodiam

Some 27 miles south-east of Kingscote as the crow flies stands the restored station of Bodiam, the southern terminus of the Kent & East Sussex Railway, whose northern terminus is at Tenterden, 10.5 miles away. The spartan station, a Holman F. Stephens light railway structure, opened in 1900 as 'Bodiam for Staplecross', half a mile away from Bodiam village with its fourteenth-century castle. It was surrounded by hop fields, which were owned mainly by Guinness, and trains would bring hop-pickers to and from the fields and transport hops to the breweries. In 1954 it closed due to falling passenger numbers and competition from the roads, but it continued to be used until 1961 for freight and occasional special passenger trains. Ten years later, it was rescued through the Tenterden Railway Company (now the KESR) purchasing the line between Tenterden and Bodiam. The company went on to reopen Bodiam on 2 April 2000. It is the ambition of the Rother Valley Railway Ltd, formed on 22 May 1991, to restore the missing rail link, approximately 3.5 miles in length, between Bodiam and Robertsbridge.

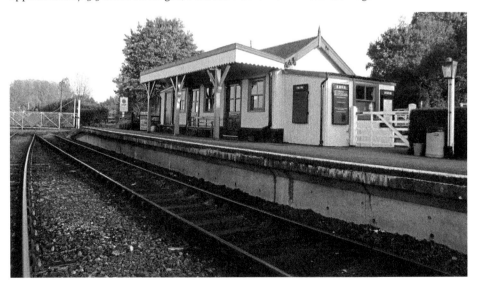

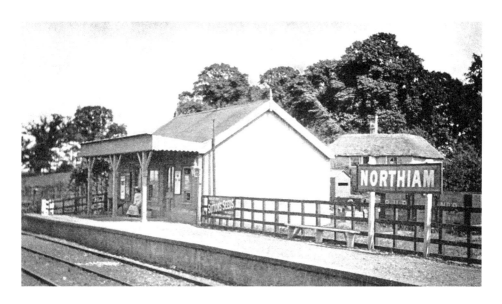

Northiam

This was another of the original stations on the 12-mile Rolvenden–Robertsbridge line opened by the Kent & East Sussex Railway in 1900. Passenger and goods services were withdrawn in 1954 and 1961 respectively, but the station was reopened on 19 May 1990 by the KESR. The similarity between it and Bodiam station – both original Stephens buildings, spared thanks to BR's non-intervention after closure on account of continuing arrivals by hop pickers' trains and specials – is striking. A second station building has been built to house conveniences, the old goods office has become a buffet and the goods yard has been replaced by a car park, where two original wooden staff bungalows are now used as a base for volunteers.

The photo below was taken on 25 October 2015 from the back of the tender of *Norwegian*, a Norwegian State Railway 21c Class 2-6-0, one of the KESR's stock of fifteen steam locomotives.

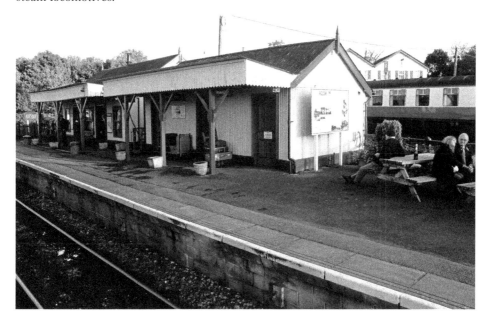

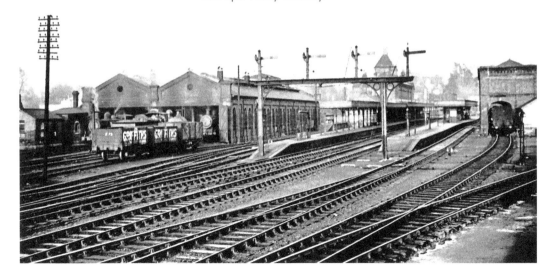

Tunbridge Wells West

In neighbouring Kent, there are two Tunbridge Wells stations, opened by rival companies, the SER and the LBSCR, in 1845 and 1866 respectively. The qualifiers 'Central' and 'West' were assigned to them in 1923. The much-larger LBSCR (West) facility was the eastern terminus of the East Grinstead, Groombridge & Tunbridge Wells Railway and would serve six different routes. Whereas the Central station still operates today, the West facility was closed to main-line passenger services in 1985 and the goods shed has been lost. Fortunately, the line as far as Eridge (see overleaf) has survived, being run since 1996 by the Spa Valley Railway, which also uses the old loco shed (former Code 75F) for repairs and maintenance, as evident from the view below taken on 6 March 2016. The splendid station building in the distance is likewise intact and thriving as a Smith & Western restaurant and hotel. A Sainsbury's car park covers the rest of the former station area.

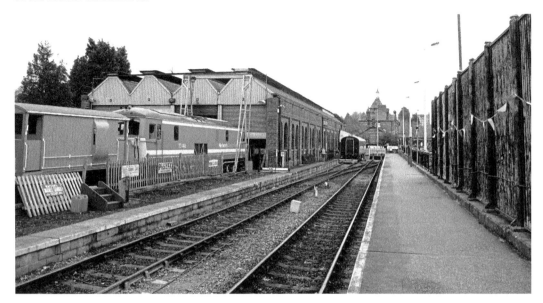

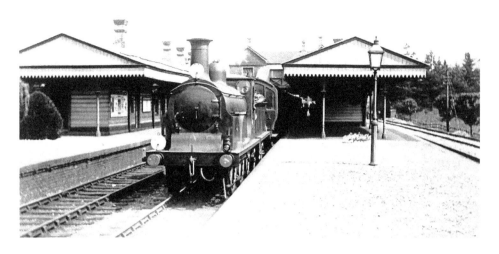

Eridge

Eridge Station was opened in 1868 as a very simple station with one platform for the single line from Uckfield to Tunbridge Wells. No passing loop was provided and there were no signals or signal box. It was rebuilt in 1880 with two island platforms, one for each route, when the line to Eastbourne opened. Later years saw expansion, prosperity and decline. Today, Southern trains from London Bridge, East Croydon and Uckfield call at Platform 1. Through the major achievement of a connection from Groombridge, realised on 25 March 2011, the Spa Valley Railway operates services from platforms 2 and 3 (left side of photos).

Our early image above, a Pouteau postcard published in around 1905, portrays an unidentified 0-4-2 B1 ('Gladstone') on a Tunbridge Wells–Brighton service. The author's photograph below shows the apparent anomaly – due to singling of the line – of the same track being used by the receding 15.03 service to Uckfield on 12 January 2016.

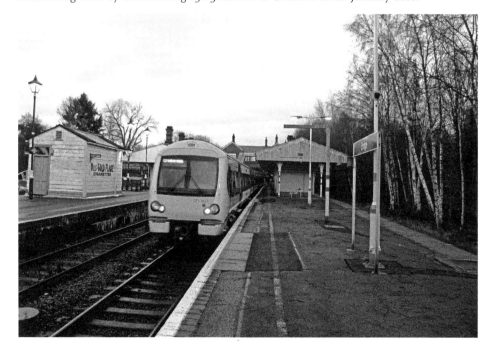

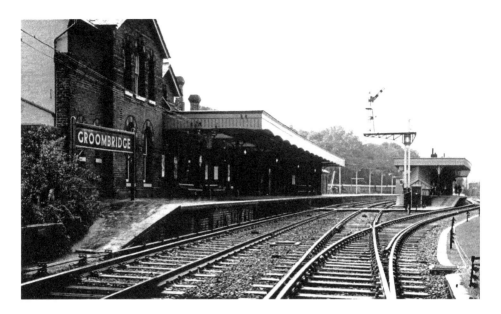

Groombridge

Straddling the border with Kent is Groombridge Station, once important as a junction. It opened in 1866 on the Three Bridges/East Grinstead to Tunbridge Wells Central station line, with which routes converged respectively from Uckfield in 1868 and from Hailsham (the Cuckoo Line) in 1888. Another arrival was the cut-off line from Oxted linking from the north-west in 1888. Groombridge comprised staggered platforms linked by a subway and was traditionally a well-kept station, beautified by a lawn and flowerbeds. Closed on 8 July 1985, it was rescued by preservationists represented today by the Spa Valley Railway. Groombridge's original station house survives in residential and commercial use, complemented by the SVR's new station buildings, platform and signal box. These are behind the photographer in his eastward-facing picture below, which clearly illustrates the loss of the island platform featured in the 1952 photo.

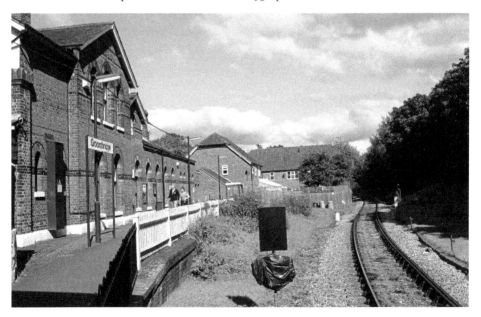

PART 3
Tramways and Branches

Rye and Camber Tramway

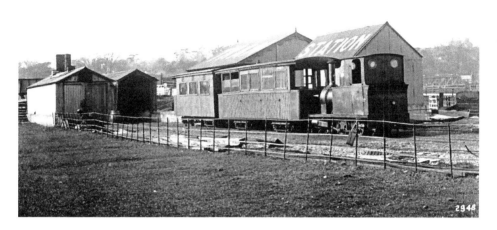

Rye and Camber Tramway

This small railway, like the Hundred of Manhood & Selsey Tramway (see page 50), was one of a number operated by consulting engineer Holman F. Stephens. The 3-foot gauge line, opened in 1895, was approximately 1.75 miles in length and linked Rye to the coast. It had three stations: Rye (featured here with 2-4-0T *Victoria* and her coaches at the platform), Golf Links, which has survived virtually intact, and Camber Sands.

When war came in 1939, the passenger service was discontinued but the line proved useful during the conflict for the conveyance of war-related material. The run-down railway was sold for scrap in 1947 and the operating company was liquidated two years later. Nothing remains of the Rye terminus, where a pumping station (on the left in the photo taken on 4 September 2015) has supplanted the engine shed. The path does at least reveal the course of the railway.

45

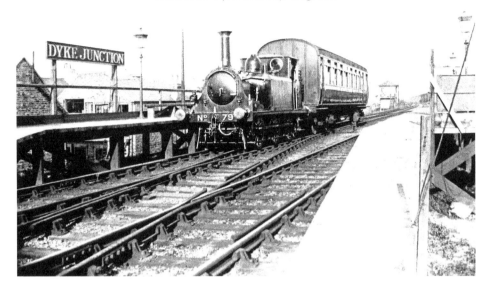

Dyke Junction Halt/Aldrington

Over the trailing crossover normally used by goods trains leaving Hove Electric Lighting Company's sidings, Class A1 'Terrier' o-6-oT No. 79 *Minories* reverses its coach away from Dyke Junction Halt in around 1910. New motor-train carriages were introduced in 1906, the year after this timber platform halt was opened. It was one of a number of small halts especially introduced for motor trains, the others including Holland Road and Fishersgate (both of which opened in 1905). Bungalow Town, Shoreham, was opened in 1910 and later renamed Shoreham Airport. Devil's Dyke trains veered off in a north-westerly direction from Dyke Junction Halt at a point above the small underpass, initially on a course roughly parallel with Amherst Avenue. Dyke Junction Halt was renamed Aldrington Halt on 17 June 1932. Today it is simply Aldrington, whence we see the 16.01 service to Brighton receding on 28 September 2015 in the photograph below.

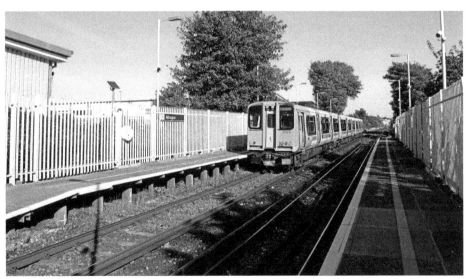

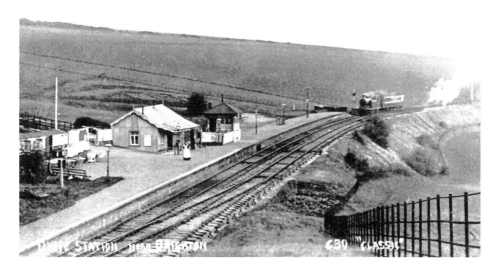

Dyke Terminus

The standard-gauge scenic Devil's Dyke railway was opened on 1 September 1887 and closed on 31 December 1938. Demolition followed. It ran the 5.5 miles from Brighton via Dyke Junction to 200 feet below the summit of Devil's Dyke, and enjoyed considerable popularity in the early days before falling victim to competition from cars and motor buses. The basic facilities that greeted visitors at the station included a converted railway coach offering tea and cakes. A small section of platform has survived.

The site now forms part of a beef production farm (the present farmer's grandfather ran the enterprise as a mixed farm from 1926). The comparative view, photographed on 13 March 2016, was taken near the iron fencing seen in the early picture – fencing which is now inaccessible, disintegrating and being replaced. The large barn of Devil's Dyke Farm stands on the precise site of the gabled and canopied station building. The course followed by the railway can be discerned in the distance.

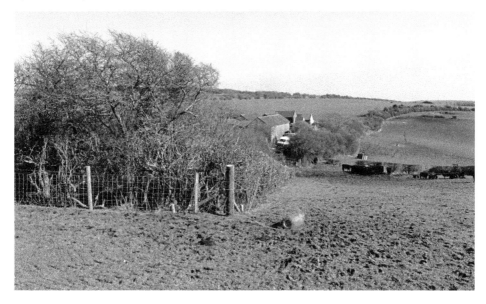

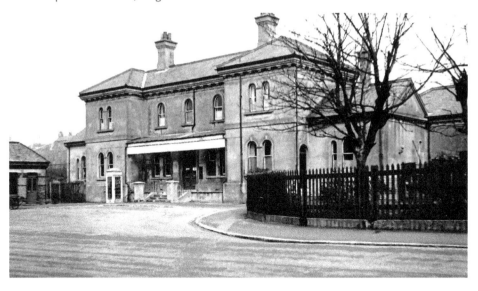

The Kemp Town Branch (1)

This short branch, measuring 1.5 miles from the Brighton/Lewes junction, was heavily engineered and costly to build, but achieved its purpose of blocking any rival entering Brighton from the east and, of course, of serving this rapidly growing residential area to the east of Brighton. When the line opened on 2 August 1869, the local press described its terminus as 'an appropriately handsome building', pointing out also that it was nearer to Brighton racecourse than the main-line terminus; hence passengers could avoid 'some portion of the hill'. It was similar in design to those at Hove, West Worthing, Shoreham-by-Sea, Portslade and London Road (Brighton). Although Brighton station was only about a mile distant by road as opposed to the 2.25 miles or so by rail, the LBSCR charged very competitive fares. Ultimately, however, the tram and bus won.

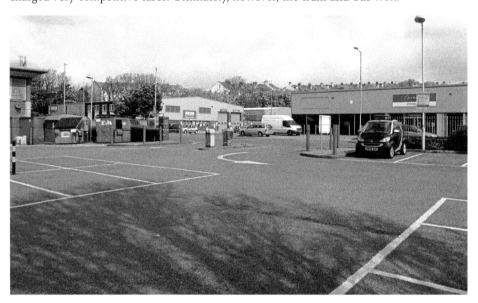

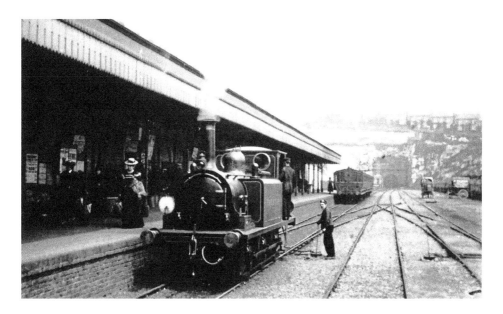

The Kemp Town Branch (2)

This splendid late 1890s view of Kemp Town station interior by the noted railway photographer Maurice Bennett shows 'Terrier' No. 63 *Preston* reversing in the course of running round its train, with passengers making their way towards the exit (the station building was behind the photographer) as the points are changed. In the background may be seen a diminutive signal box to the left of the lengthy (1,024-yard) single-bore tunnel set in the chalk cliff. The portal can be discerned (just) in the 'now' photo taken on 23 September 2015. From 1906, a half-hourly rail motor service was introduced to meet local competition from electric trams but the wartime and post-war closure of the station between 1 January 1917 and 10 August 1919 resulted in passengers transferring their allegiance permanently to the roads. Kemp Town finally closed to passenger traffic in 1933 and to freight in 1971. Its site is now occupied by the Freshfield Industrial Estate.

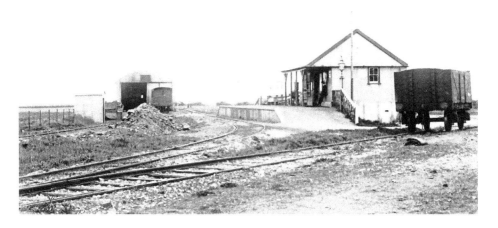

Selsey Town

Selsey Town station was the terminus of the standard-gauge line from Chichester of the Hundred of Manhood & Selsey Tramway (August 1897–January 1935), which from 1924 was known as the West Sussex Railway (Selsey Tramway Section). Within the 8 miles of railway, there were no fewer than eleven stations and halts, including the private ones. A half-mile southward extension to 'Selsey Beach Station' operated from 1898 to 1916.

In 1910, seven trains ran daily in each direction, with eight on Mondays and just three on Sundays. Declining traffic through road transport competition ultimately led to the closure of the line.

The author has established, from available evidence, that the station was located where Allandale Close stands today (the online Selsey Heritage Project corroborates this). In the background the roofs of houses in Beach Road (in the row numbered 21–25a) serve as a reference point.

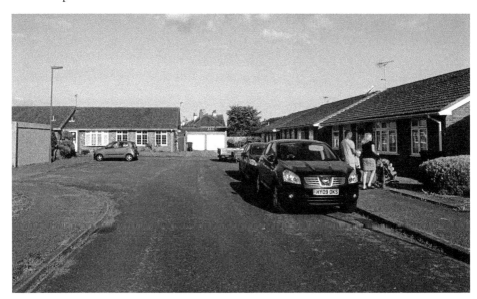

Operational Mainline Stations

The Brighton Line

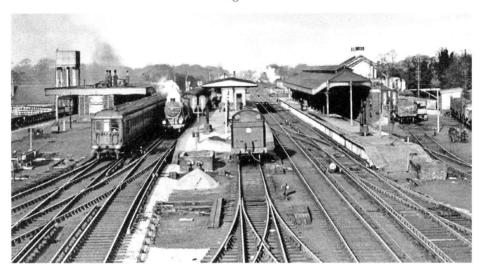

Three Bridges

The station near the hamlet of Three Bridges was opened in July 1841, becoming the site of an important railway junction in 1848 with the opening of the branch line to Horsham and thence to Portsmouth. A further branch line to East Grinstead was opened in 1855.

The splendid O. J. Morris postcard above depicts the station on 31 December 1932, the eve of the full electrification of the London–Brighton main line. No. 798 *Sir Hectimere*, a 'King Arthur' Class locomotive, stands at Platform 3 on a Down train, flanked by four-car electric unit No. 2949 arriving on the Up slow line. On the extreme left is the Mid-Sussex line to Bognor via Horsham and, over on the right, the fully canopied bay for the East Grinstead service.

In the photo below, taken on 7 August 2015, a Brighton-bound train passes Platform 5 (right) and a London service stands at Platform 2 (left).

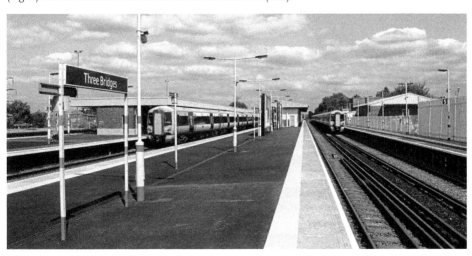

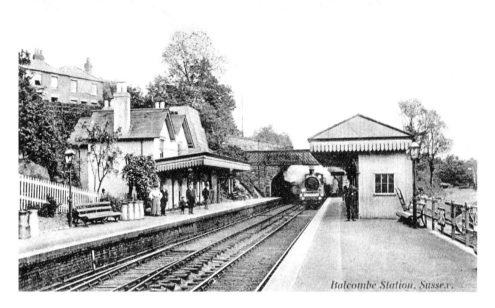

Balcombe Station, Sussex.

Balcombe

Located between the busy stations of Three Bridges and Haywards Heath, this station retains its country feel despite the many through trains, with its typical off-peak service of one train per hour to Brighton via Burgess Hill and one per hour to London Bridge via Gatwick Airport and East Croydon. One such is the Class 377 EMU, seen below hurrying through the station on 22 June 2015.

Opened in 1841, initially a little to the north of here, by the London and Brighton Railway (later LBSCR), Balcombe has undergone many structural changes since its re-siting in 1848. These include the addition of a new booking office and waiting room in 1879, the disappearance of the two-storey station building, the repositioning and replacement of the iron footbridge by a concrete one, the northward lengthening of the platforms and the loss of the signal box. Yet the distinctive gentlemen's toilet block survives, disused, on the Down platform.

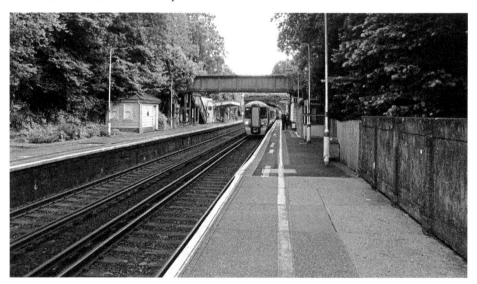

Haywards Heath

In the photograph above, we are looking south in 1898 from today's platform 3/4 over the road bridge. In the siding on the left stands a D3 0-4-4T with her train. A crossover links the two main lines. The station, another David Mocatta design, started life as a terminus from Norwood on 12 July 1841, with passengers being conveyed onward by coach to the coast for two-and-a-half months until the line to Brighton was opened. It became a significant junction through a later link to Lewes (1847) and the opening in 1883, via Copyhold Junction just north of the station, of a double-track branch line to Horsted Keynes. This was closed to passengers in 1963.

In 1932, the station was extensively rebuilt ahead of electrification. The cranes in the photo below, taken on 4 October 2015 and dominated by lift towers, are evidence of the £35 million regeneration (due for completion in late 2016) currently taking place here.

Wivelsfield Station, Sussex ,showing the Through Manchester to Eastbourne Train coming from London'.

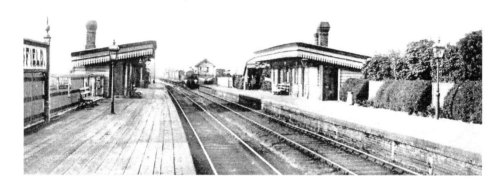

Wivelsfield

Postcard publisher A. H. Homewood of Burgess Hill has left us a valuable record of Edwardian rail travel with this view (above) of an approaching inter-regional express. Although not named here as such, this is doubtless the Sunny South Express, which ran from Liverpool and Manchester to Brighton and Eastbourne from 1904 until after the Second World War.

Opened as late as 1886, Wivelsfield station is located just north of Keymer Junction, where the line for Lewes and Eastbourne diverges from the Brighton Main Line. Its name was not changed to Wivelsfield from that of its 1862 Lewes-line predecessor (Keymer Junction) for ten years. A landslip during its construction caused a long section of the Up (northbound) platform and the waiting room building to collapse and fall down the embankment, which was being widened.

The photo below shows the – extended – LBSCR shelter being passed by a Brighton-bound Class 377 service on 21 June 2015.

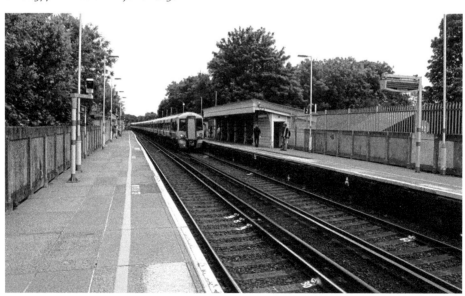

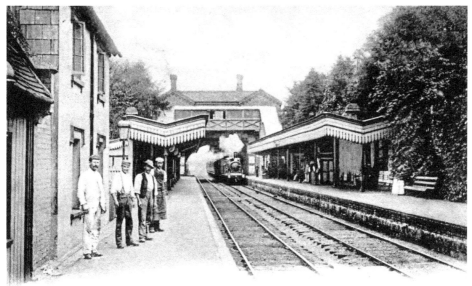

Burgess Hill Station.

Burgess Hill

The image above appears to date from the late 1890s and shows the 1877 station building up at road level. The first station was opened on 21 September 1841 and stood some distance to the south of the footbridge in the background. The canopies today reflect the form, but not the ornateness, of the earlier structures.

The station house of around 1850 on the left and a coal merchant's office (not visible) beside Platform 2 opposite were demolished in the 1980s. However, the wooden shed, now brick, that is partly visible on the extreme left was spared. Originally a waiting room erected in 1853, it was later used as a parcels office and survives between Platform 1 and the former western goods yard, which closed in 1964. Near to it, the goods shed also survives as the premises of a salvage and reclamation firm whose yard occupies much of the area of the former sidings.

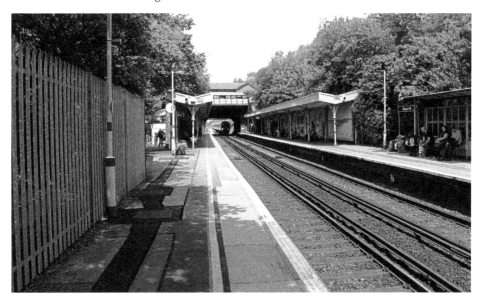

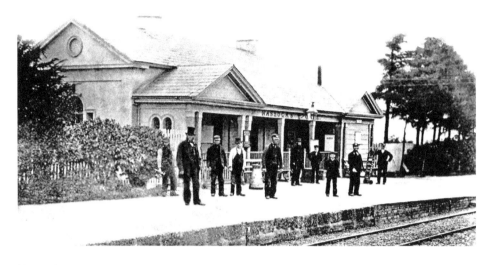

Hassocks

The next station south is Hassocks, which has seen several rebuilds. Above, showing the low Up platform built of old stone sleepers, is an 1870s view of the distinctive first station. Designed by David Mocatta (architect of Brighton station), it was opened on 21 September 1841. Its name then – inscribed across the building – was Hassocks Gate and this was used until 1 October 1881. The building subsequently served as a cottage until 1973. There were originally four tracks, two for through-expresses.

In 1880/81 a new Thomas Myres station building was constructed, comprising a half-timbered upper storey, decorative brick eaves, stained glass windows and rustic porches. A lantern-shaped roof covered the booking office and the platforms were sheltered by wooden canopies on iron columns. The building was demolished in 1973 by British Rail, to be replaced by an unattractive CLASP (cheap prefabricated) structure, itself supplanted by a new building, officially opened on 5 July 2013.

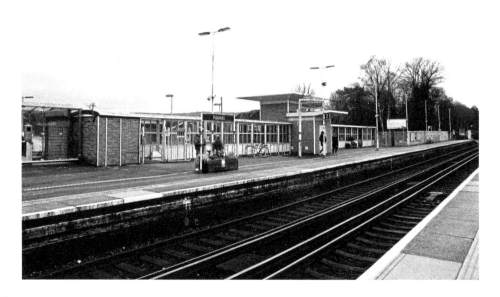

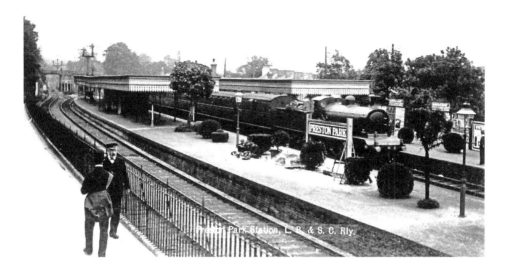

Preston Park

The slightly elevated earlier view (above) of Preston Park station, which lies not far north of Brighton, was probably taken from the now inaccessible embankment between the railing-lined walkway and parallel Woodside Avenue. Apart from the loss of the trees, shrubs and the north signal box, little appears to have changed since well-known postcard publisher Arthur H. Homewood of Burgess Hill photographed the waiting B4 at today's Platform 3, although the station has lost the track in the immediate foreground and one at the very far side of the station.

Preston Park station was opened on 1 November 1869, following agitation for a station to serve the new housing north of Brighton. Today's view shows the arrival at 12.38 of a London Bridge–Littlehampton service, while a train of empty stock bound for Brighton waits on the left at Platform 1.

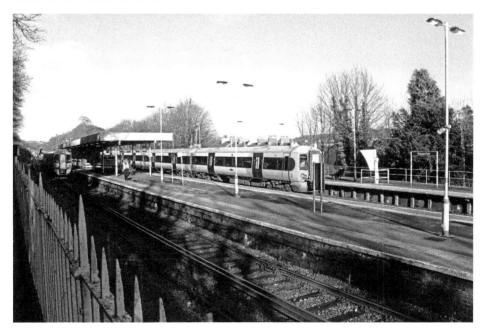

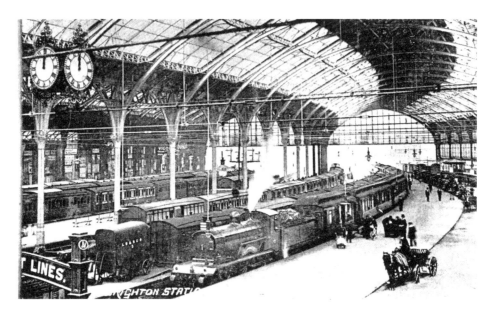

Brighton

The dominant feature common to both the images here is the magnificent double-spanned curved glass and iron trainshed roof, installed as part of the major renovation – effectively a rebuild – of the station in 1882/83. The clock, which underwent a £25,000 overhaul in 2012, also dates from that time.

The station (now Grade II*) was built by the London & Brighton Railway in 1840/41, its house comprising an elegant three-storey Italianate-style structure designed by David Mocatta. The first rail connections made were to Shoreham-by-Sea to the west (11 May 1840), London Bridge to the north (21 September 1841) and Lewes to the east (8 June 1846). Services to and from London Victoria began on 1 October 1860. Eight platforms are currently in use (eleven in 1882/83).

In October 2013, a £5 million transformation of the concourse was unveiled. Estimated annual passenger usage rose from almost 11.3 million in 2004/05 to almost 17.2 million in 2014/15 – an increase of over 52 per cent.

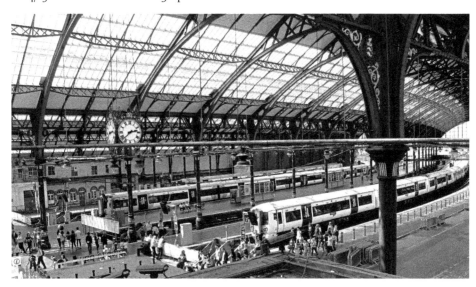

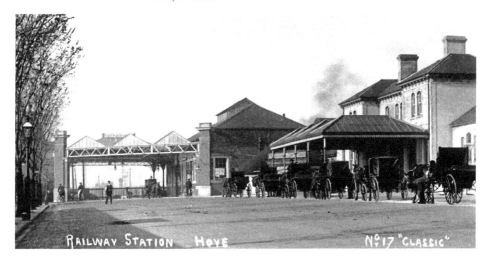

Hove

Since its opening in May 1840 on the Brighton–Shoreham line – the first passenger-carrying line in Sussex – this station has had five different names: Holland Road (1840); Cliftonville, after re-siting further west (1865–79); West Brighton, when a new station was built immediately adjacent (1879–94); Hove and West Brighton (1894–95) and finally Hove (1895–present).

The original station building, on the right in both pictures, dates from the second station's opening in 1865 and is very similar in design to the buildings at West Worthing, Shoreham-by-Sea, Portslade, London Road and Kemp Town in Brighton. It stands south of the line and east of the present ticket office and concourse (built in 1893 and visible in the background).

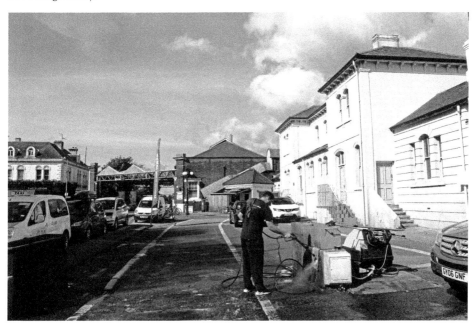

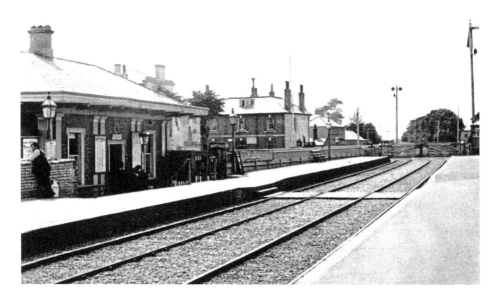

Shoreham-by-Sea

This 1870 view of the station, later published as a postcard, interestingly shows three different types of early signalling. An 1886 picture reveals raised platforms, the old building fenced off, the provision of a subway (closed off in 1988) and a new signal box.

Shoreham station was opened as a terminus, amid great celebration, on 11 May 1840 by the London & Brighton Railway, making it the first public railway in the county. The original building was demolished in 1845 when the Brighton & Chichester Railway opened its line to Worthing. Both railways merged with others in the following year to become the LBSCR.

In 1861, a single track from Shoreham to Horsham was opened, providing an alternative route to London. It was doubled a few years later and was eventually closed to passengers in 1966.

The station was renamed Shoreham-by-Sea on 1 October 1906.

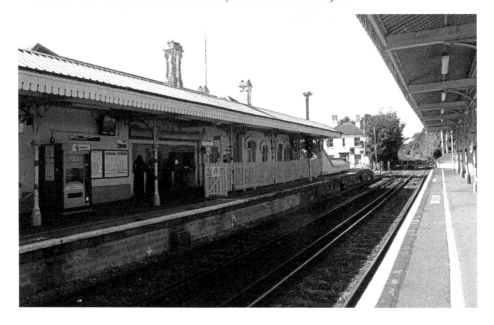

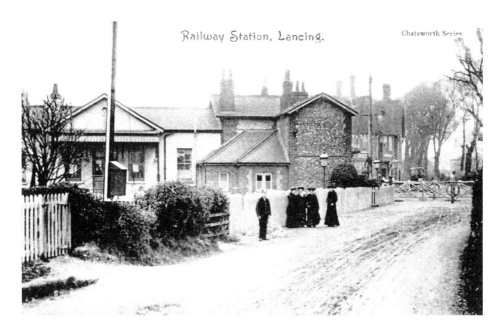

Railway Station, Lancing.

Chatsworth Series

Lancing

The survival of the original (1845) station house, with its knapped flint walls and brick quoins, seems miraculous. The building, unusually at right angles to the track, is occupied today by a taxi firm, which about five years ago (on taking over the premises) removed the entrance porch, just visible on the right side of the building in the early picture. Also visible is the Up starting signal by the crossing gates. In the background is the Railway Hotel, renamed The Merry Monk in about 1973. Long gone is the rural line of mature trees in North Road beyond the crossing.

To the left of the station building is the comparatively plain ticket office of 1893, the operational centre of the station today. The iron footbridge with lattice sides, ascending beside the former station house, was removed in March 2016 for refurbishment and repair. A short video published online by the *Worthing Herald* recorded the event.

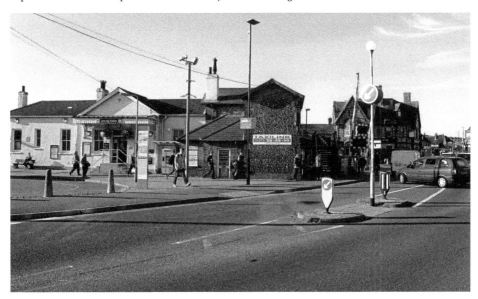

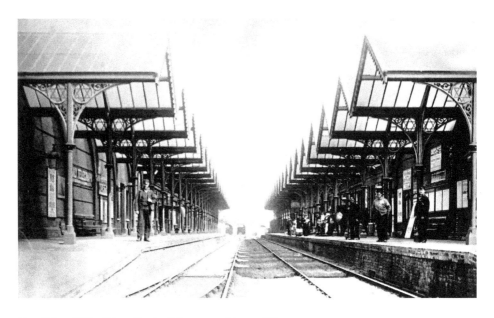

Worthing ('Worthing Central' from 1936 to 1968)

Little public celebration greeted the opening, on 24 November 1845, of the first of three stations in the town. Despite the agitation for it during the rest of the century, a direct line northwards from Worthing to London never materialised. The August 1882 photo above is an excellent record of the town's second station (1869–1908), a single-storey brick block. The roof supports of the three Midland-type platform canopies – unique in Sussex – that survive interestingly feature the Star of David. Refreshment rooms were provided in 1879. Between November 2007 and February 2008, this important interchange, whose annual estimated passenger usage exceeds 2.5 million, was repainted in the new Southern Trains colours and the canopy roof glass was replaced.

The present-day photo below records the 17.22 First Great Western service from Brighton to Bristol Temple Meads entering the station on 28 September 2015.

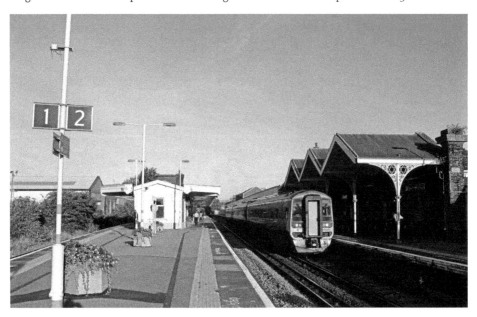

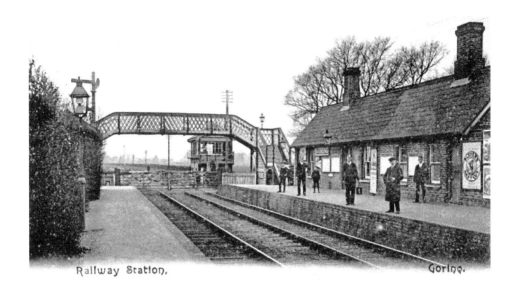

Railway Station, Goring.

Goring-by-Sea

Opened on 16 March 1846 and renamed Goring-by-Sea in 1908, this station has remained relatively unchanged down the years, although a generous canopy has been provided on Platform 1 (for trains to Worthing, Brighton and London) and the signal box is no more. A cattle pen and a goods yard, which closed in 1962, once stood south of the westbound line just beyond Platform 2. Today the elegant terraced houses of Bluebell Way occupy the site. The wide, open fields opposite them lend a rural air to this location. However, the station is far from quiet; estimated annual rail passenger usage rose from around 374,000 in 2004/05 to approximately 577,962 in 2014/15 – an increase of 54 per cent.

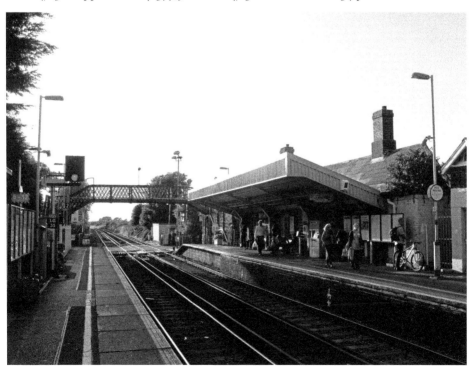

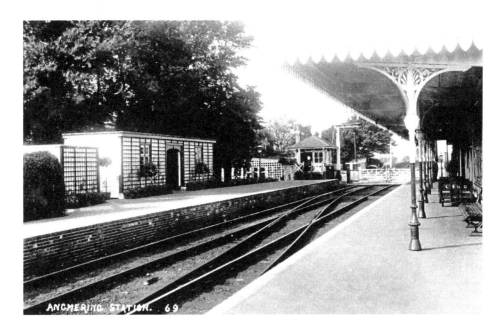

Angmering

Situated roughly half a mile from the centre of Angmering village and serving also the nearby villages of Rustington and East Preston, Angmering station was opened in 1846 and replaced in the 1860s. Its signal box, long since removed, dated from 1877 (there was once a remembrance garden for an old signalman on Platform 2, tended by elderly local ladies). The station house still stands. The unusual trellised shelter in the early (c. 1908) view has been replaced by a 'bus shelter', while there are ample cycle storage facilities and the crossing has been modernised. A concrete bridge well behind the photographer now links the platforms; near it, the goods shed survives. Unusually, a 'hole-in-the-wall' buffet on Platform 1 has provided a welcome service since late June 2006.

Station patronage rose from 0.526 million in 2004/05 to 0.883 million in 2014/15. The receding train, photographed on 9 September 2015, is the 13.33 Brighton–Southampton Central service.

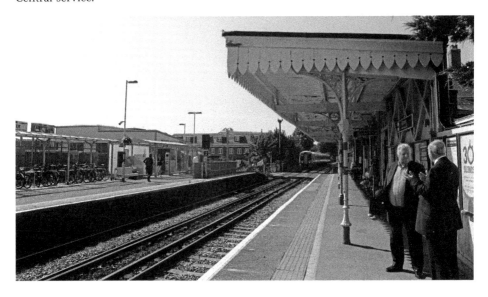

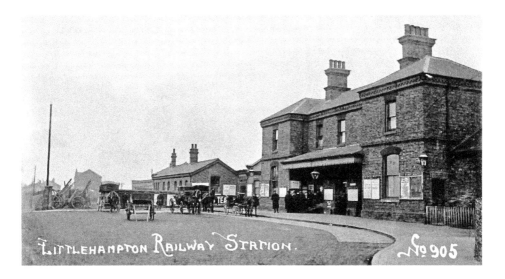

Littlehampton

On 31 August 2013, Littlehampton celebrated the 150th anniversary of the arrival of the railway in the town with a varied programme of events. From July to September, an exhibition entitled 'Littlehampton 150' vividly told the whole story.

Before the branch opened on 17 August 1863, the town was served by a station called Arundel and Littlehampton, which opened in 1846 on the main Brighton–Portsmouth line near the present Lyminster crossing. In 1887, the third side of the triangle was constructed, allowing through running from the lines from Horsham and Brighton.

A station building (see above) similar to that at Arundel, Portslade and West Worthing was provided. On demolition in 1937, its proper replacement was delayed by the war and planning disputes, the town being served for fifty years by a temporary wooden terminus. Goods traffic was handled until 1970. Not until 15 January 1988 was the present station officially opened.

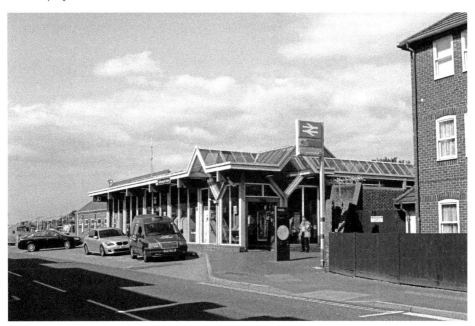

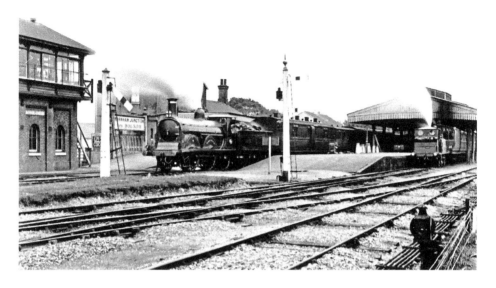

Barnham (formerly Barnham Junction)

This fine sepia study by O. J. Morris depicts 'Gladstone' loco No. 220 *Hampden* on a Victoria–Portsmouth service in 1900. On the right, a 'Terrier' tank (probably No. 77 *Wonersh*) blows off with a Littlehampton–Bognor train at today's Platform 1, which still serves the short branch. The fine signal box, re-sited at the west end of the Down platform three years later, has gone now but is not lost, being used locally at Aldingbourne by Bognor Regis Model Railway Club.

Today, platforms 2 and 3 at this busy junction cater for westbound services towards Chichester, Portsmouth and Southampton and Bognor from London, and for eastbound services towards Littlehampton, Brighton and London, respectively. In addition, Great Western Railway operates two services per day to Bristol Temple Meads via Southampton Central, Salisbury and Bath Spa, with one continuing to Great Malvern via Gloucester, Cheltenham Spa and Worcester.

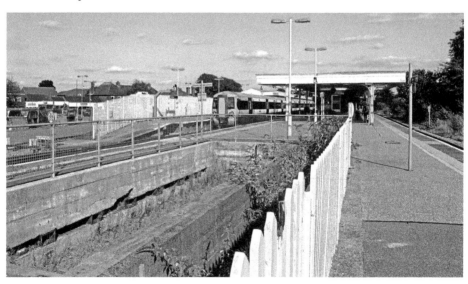

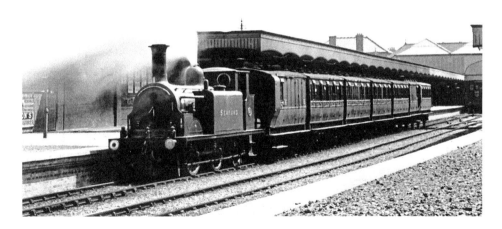

Bognor Regis

Bognor (Bognor Regis from 1930) station opened in 1864, linking the town with Barnham. Its present elegant buildings date from 1902, following a chapter of disasters in previous years, namely abortive projects to connect the town to the railway system in 1845, 1853 and 1855, destruction by a gale in 1897 and a catastrophic fire in 1899. Its fortunes changed between 1902 and 1911 with the doubling of the line and, in the 1930s, with the arrival of electrification. Restoration and Grade II listing came in 1993/94, this being recorded on a now rather worn blue plaque on an outside wall of the building. In a smaller plaque above it, Network SouthCentral and Railtrack acknowledge the various contributors to the cost. Estimated passenger usage rose by a full 30 per cent between 2004/05 and 2014/15 (from 0.951m to 1.2367m).

The comparative images show, respectively, 'D' Class tank No. 228 *Seaford* waiting to leave for Barnham in 1902 (above) and various units at the platforms on 6 September 2015 (below).

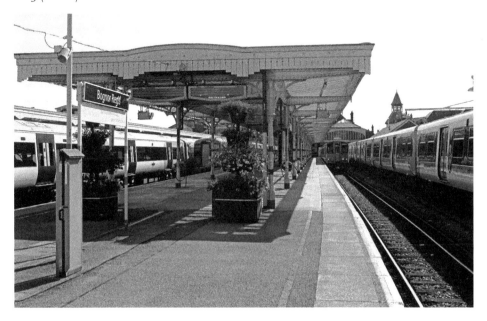

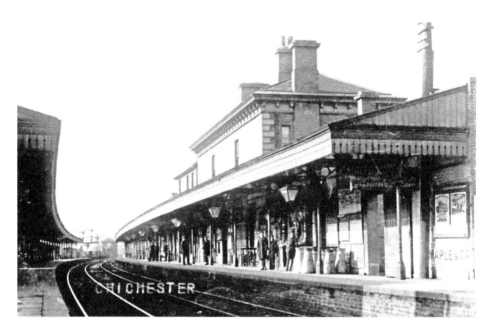

Chichester

Located near the city centre, Chichester station on the Brighton–Southampton West Coastway Line received its first train in 1846. Remodelled by T. H. Myres in 1881, it underwent improvements soon after the Grouping. The extensive 'Festival of Britain' style rebuild of 1957/58, with its light and airy booking hall, was described by John Hoare in his book *Sussex Railway Architecture* (1979) as 'an outstanding example of a public building'. The station has lost three platforms, with the Up side bay platform for most Midhurst services filled in for additional car parking in 1986. Chichester was from 1897 until 1935 the terminus of a light railway to Selsey (see page 50).

A covered footbridge allows pedestrians to cross when the barriers of a busy platform-end level crossing are down. The station and most trains are operated by Southern, with a limited number operated by Great Western Railway.

Our westward views show the station in around 1910 (above) and on 24 May 2016 (below), with the signal box and approaching 17.00 service for Brighton in the far distance.

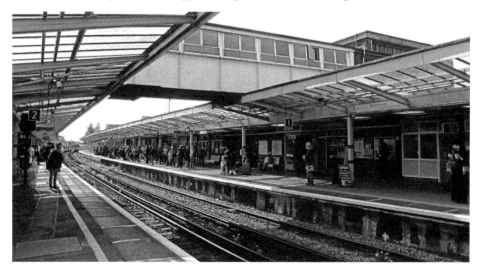

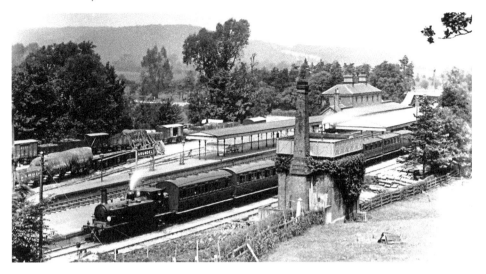

Arundel

When the Arun Valley line was extended to here in 1863, a condition of the sale of the land by the Duke of Norfolk was that all London-bound trains had to stop at Arundel. Today's station at Ford, 3 miles to the south on the coastal route, was actually named Arundel from opening in 1846 until 1863.

The splendid panorama of Arundel station in 1901 features D1 class engine No. 10, *Banstead*, in the Down bay on a Littlehampton and Bognor-bound train. In the photograph taken on 6 September 2015 from attractively verdant public land, the station is somewhat obscured but the scene has not greatly changed, save mainly for the closure of the extensive goods yard in 1963 and its subsequent replacement by a car park, and the lifting of the Down bay track in 1977 following cessation of use in 1972. The main office building and (not visible here) the large goods shed have survived fairly intact.

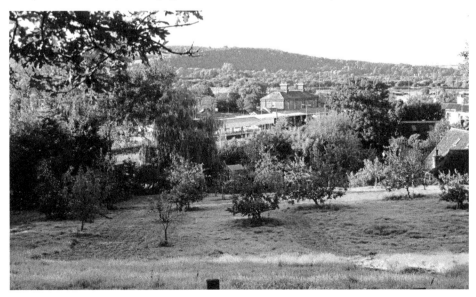

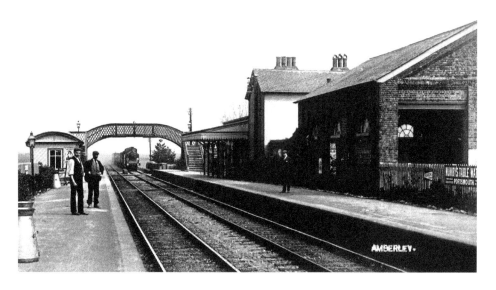

Amberley

In his 1979 book *Sussex Railway Architecture*, John Hoare describes the LBSCR's station at Amberley as 'a pleasing and characteristic ensemble of 1863', praising also the (now lost) goods shed. A footbridge was added in 1891. Among this station's unusual features were the re-siting in 1934 of the signal box from its traditional position onto Platform 2 beside the booking office and, from April 1894 until August 1968, the dual use of that office as a post office. The station house has been lost, thanks to BR, but the adjacent booking office survives, albeit boarded up. There is free parking at all times.

The popular Amberley Museum and Heritage Centre, built on the site of Pepper & Son's chalk pits and lime kilns, is accessed from the former station goods yard. In today's view (below) we see the approach, on 7 September 2015, of the 16.25 service to Bognor.

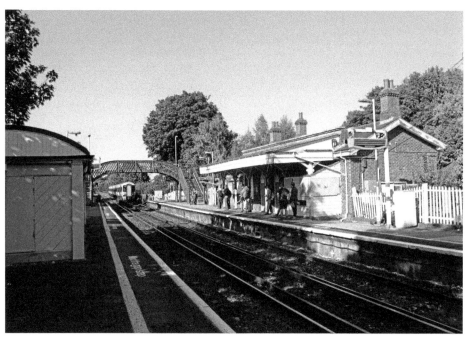

Pulborough

This west-facing island platform looking north, and its surroundings, present features of interest. In the background of this loop line, on which steam-worked services to Midhurst operated until 1955, is a Grade II listed LBSCR Saxby & Farmer Type 5 signal box, built in 1878 on the then Crawley–Littlehampton railway. The turntable by the water tower was little used in the later years of the branch, as most services were worked by push-pull trains. Some distance on the left, behind the photographer, once stood the railway's cattle dock and pens.

The first railway to reach Pulborough was that from Horsham to Petworth, which opened on 10 October 1859 and extended to Midhurst in 1866, when this and Billingshurst were the only two intermediate stations. A link to the Brighton–Portsmouth line was made four years later. The goods yard was closed in the mid-1960s and is now a car park.

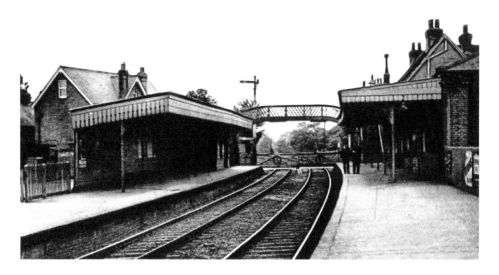

Billingshurst

When built by the Mid-Sussex Railway on the line from Horsham to Petworth on 15 October 1859, Billingshurst station stood in a ploughed field over half a mile away from the village. Yet it was to have a profound influence on the development of the local community.

Structurally the station has seen little change since then. The goods shed has survived, attached to the main building as at Pulborough, and is used by a tyre company that also occupies part of the station house, the rest being used as a booking office. The signal box, obscured in the early picture above, was a Grade II listed structure and thought to be one of the country's oldest, dating back to 1876. It closed on 14 March 2014 and was moved to Amberley Museum and Heritage Centre just over a week later.

With its pot plants and lavender (below), Billingshurst is an attractive and well-kept station.

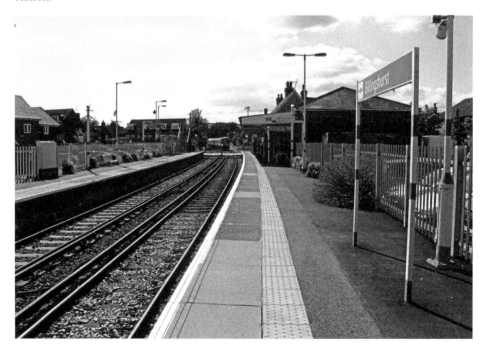

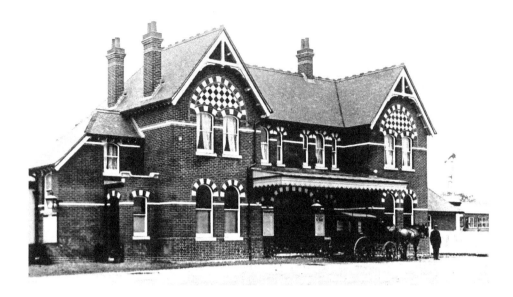

Christ's Hospital

This imposing station building cost £30,000 to build from 1899 to 1902 – nearly £3 million in today's terms. Yet it only lasted until 1972. Praised by architectural critic Nikolaus Pevsner as 'West Sussex's only memorable railway station', it was demolished despite the plea for its preservation in its original form from fellow writer Ian Nairn.

The station was opened by the LBSCR as 'Christ's Hospital, West Horsham' on 28 April 1902, primarily to serve Christ's Hospital, a large independent school that had just moved to the area from London.

Although it did become a junction of some importance, its inevitably severe rationalisation came in 1972. The LBSCR had seriously overestimated its use by the school, while the local residential development on which it had pinned great hopes never materialised – largely, and ironically, because the school had purchased much of the land around the junction and had no wish to see housing cover its green fields.

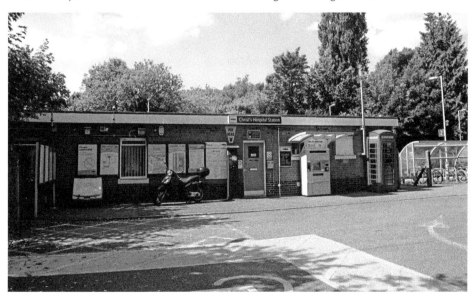

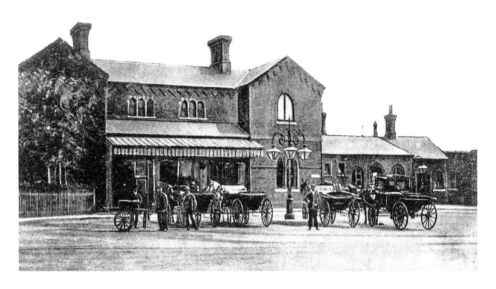

Horsham

Today's exotic picture of Horsham's 1938 station (below) was obtained standing on the island of a busy roundabout. The Grade II listed building, constructed by the Southern Railway in the International Modern style, seems attractive enough, yet it was decried by Nairn and Pevsner in their *Buildings of England – Sussex* (1965) for its 'really horrible front'. Its predecessor, built in 1873–76 and shown above, is hardly prepossessing, despite some highly ornamental brickwork.

The town's first station, remembered by Henry Burstow in his *Reminiscences of Horsham* (1911) as a 'little plain wooden structure', was situated slightly to the east of the roundabout and opened on 14 February 1848. It was rebuilt ten years later. By 1861 the link with Shoreham was established and the following year saw the completion of the line through Dorking and Leatherhead to London Victoria. By 1865 there was a rail connection with Guildford.

The station underwent an extensive internal refit in 2012/13.

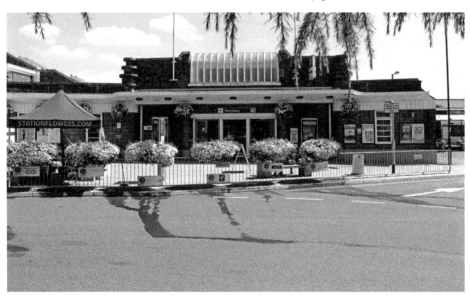

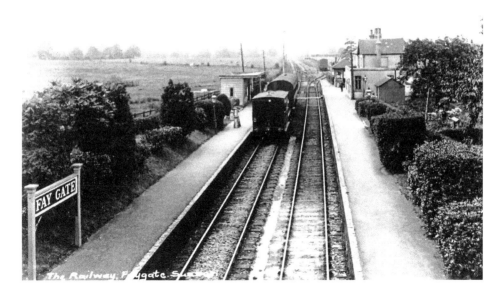

Faygate

Faygate Station (spelled 'Faye Gate' by the railway until December 1953), on the Arun Valley Line between Horsham and Three Bridges, typified a small LBSCR country station. Unstaffed, it still looks quiet today, with just eleven northbound and twelve southbound trains calling here on weekdays and none at weekends, yet passenger use more than tripled between 2004/05 and 2014/15, from 4,139 to 13,532.

The station opened in 1848. Its house has long gone, as has the signal box on the platform from which the signalman would issue tickets to passengers standing under a lean-to shelter (this was later enclosed). The goods yard closed on 8 November 1961 and the concrete footbridge added by the SR has been removed. Today, a business centre operates close to the station. Much of the housing in the adjacent village is relatively modern.

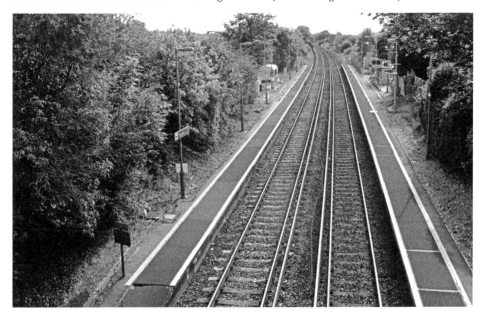

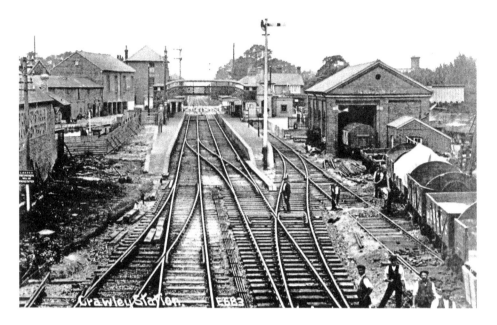

Crawley

Shown here are the station in the 1900s, serving a population numbered in hundreds, and a present-day view of its disused platforms. Crawley's replacement station, which opened on the date the old one closed – 28 July 1968 – is behind the photographer. It was funded by a six-storey commercial development above it.

Virtually all that remains that is common to the two images is the tall, chimneyed public house, the Railway (formerly the Station) Inn, and the redundant signal box of 1877 behind it, a Grade II listed building that has been partially restored. The crossing gates were removed in 1977; various businesses, the units modern in design, flourish alongside the line on the left, while a car park has replaced the goods yard on the right.

The station, first opened in 1848, is the last stop on the Arun Valley Line before this rejoins the Brighton Main Line.

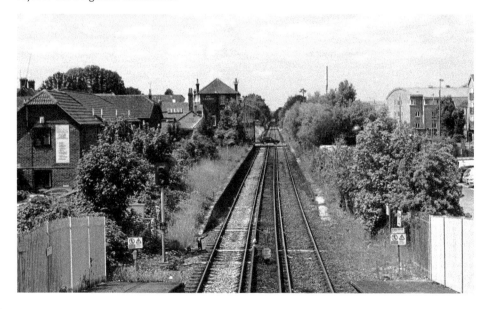

East Grinstead

The first of four stations (at two levels) at East Grinstead dated from 1855 as the terminus, well-situated for the town centre, of a single-track line from Three Bridges. It was relocated a few yards north in 1866, following extension of the line to Tunbridge Wells West, and straddled the double track, with basements at platform level. Shown above is the third station, attractively designed by Thomas Myres and built some 300 yards to the west of the second one at a right angle to it. Opening on 1 August 1882 to receive services from the Oxted Line and from Lewes, it was regrettably demolished in 1970/71. Its replacement, a prefabricated CLASP structure, was opened in 1972 immediately to the south. This was, thankfully, supplanted in 2013 by today's award-winning station, built at a cost of £2.1 million under the DoT's National Station Improvement Programme.

Nearby is the Bluebell Railway's northern terminus, opened in the same year.

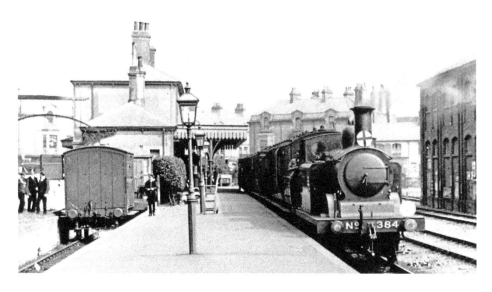

Seaford

About to depart for Lewes, on the branch that reached the town on 1 June 1864, D3 tank No. 384 *Cooksbridge* (1893–1953) stands at Seaford, designed as a through station for a proposed extension to Eastbourne that was never built. The single track was doubled in 1904 but later reverted to single-line status. Freight traffic was withdrawn in May 1964. The area occupied by the tall goods shed on the right, demolished in 1986, is now part of the car park of Seaford Health Centre, although the trackbed from the south goods yard on the left remains on 28 June 2015 (see below); the yard area itself behind the photographer is occupied by housing. Today's picture, featuring a waiting Class 313 EMU, shows that the north goods and coal yard have been cleared and the storage sidings lifted.

Estimated annual passenger usage more than doubled between 2002/03 (0.372 million) and 2014/15 (0.798 million).

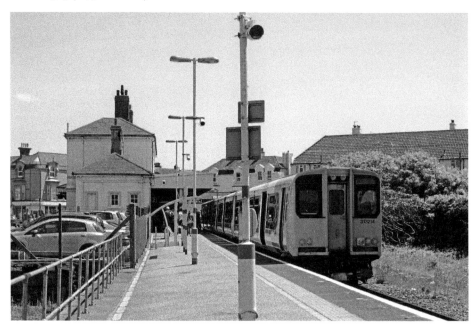

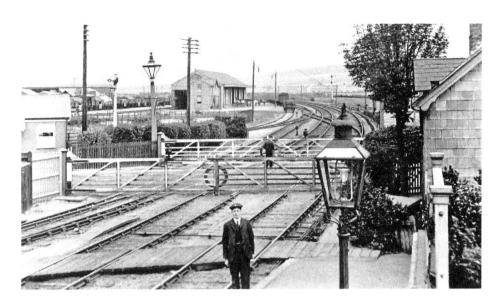

Newhaven Town

The railway came to Newhaven on 8 December 1847 from Lewes, with confident expectations of the town becoming a great port – the 'Liverpool of the South' according to an 1852 guidebook. The original station's interior dimensions were only 35 x 15 feet, including booking office, ticket counter, ladies' room and toilet. One central chimney served fireplaces in both rooms. A single-line extension to Seaford was brought into use in June 1864 and a small loco shed (sadly demolished in 2014) was opened in 1887.

Our pictures, taken from the footbridge, look north from the station. The only features common to both are the level crossing and (out of sight in the early view) the impressive and still-operational signal box of 1879. Equally impressive perhaps is the 1970s flyover, which leads away much of the traffic that would otherwise congest the level crossing area.

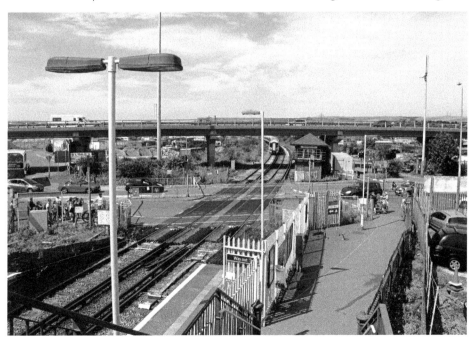

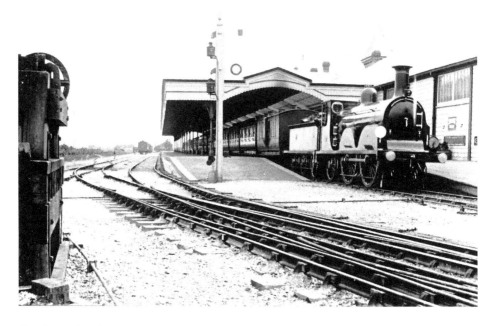

Newhaven Marine

Two goods-only/empty stock trains per day, one in the morning and one in the evening, call at Newhaven Marine station. Although legally open, it has been closed to passenger trains since August 2006 due to safety concerns regarding the roof (which was in fact removed in 2015). Although shortened in 1978, the single platform is long enough for twelve coaches. Pictured above is an unidentified 'Gladstone' class locomotive at the original station, subsequently rebuilt. Just out of sight on the far left in today's view is the line from Lewes to Seaford.

Newhaven Marine, opened on 17 May 1886 as Newhaven Harbour (Boat Station), had the third rail extended to it in 1949. On 14 May of that year, 'Schools' class 4-4-0 No. 30929 *Malvern* hauled the last scheduled steam boat train. The station was, on that exact same date in 1984, renamed Newhaven Marine by British Railways. It featured in a BBC Radio 4 programme, *The Ghost Trains of Old England*, in October 2010.

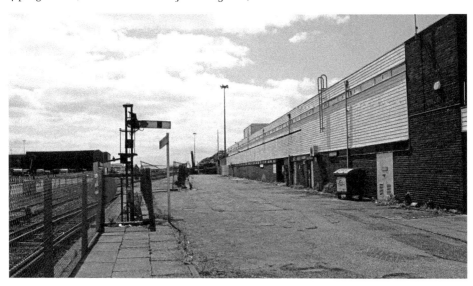

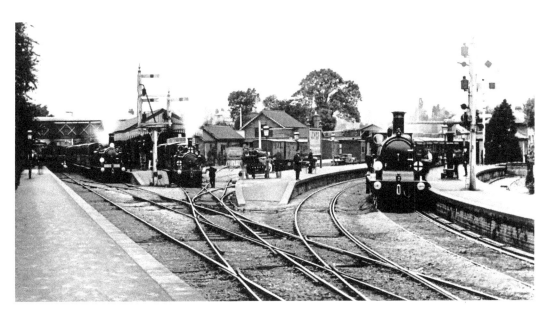

Lewes

In the image above of the glory days of steam at Lewes, the chalet building reveals that this is the second of the three stations to be built here, that of 1857. The opening of the third and present one on 17 June 1889 a short distance to the south allowed the bay to be turned into a through platform and for a number of trains to terminate at Lewes after all LBSCR services had initially run through to Brighton. The town's original station opened in 1846, with the line to Brighton being followed in that year by one to St Leonards and, in the following year, to Newhaven and Wivelsfield; in 1858 came a connection with Uckfield and in 1882 with East Grinstead.

Today's view of the busy junction – serving 2.6 million passengers a year in 2014/15 – was taken on 8 August 2015 from the footbridge east of the station.

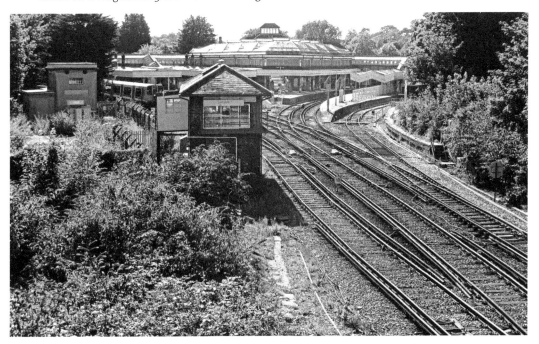

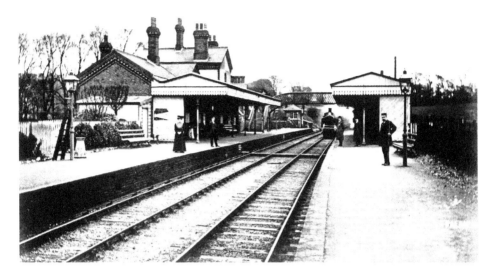

Falmer

Falmer station has somehow retained a charming country feel, despite the impact of the establishment in its vicinity of the University of Sussex (1961), the Brighton College of Education, the University of Brighton (1965 and later) and the American Express Community Stadium (2011). Estimated passenger usage nearly quadrupled between 2002/03 and 2014/15, rising from 355,367 to 1,336,334.

The original station stood approximately one mile east from here and opened on 8 June 1846. It was moved to its present location, much closer to the village, on 1 August 1865 and rebuilt in 1890. The buildings on the Down (eastbound) platform date from this time, although modern replacements have been installed on the westbound side. The 1877 signal box visible in the postcard by A. H. Homewood of Burgess Hill (above) was replaced by a booking office extension on the Down platform, which was closed on 30 March 1985 and demolished on 16–17 October 2010 in anticipation of the increased use of the platform by stadium users.

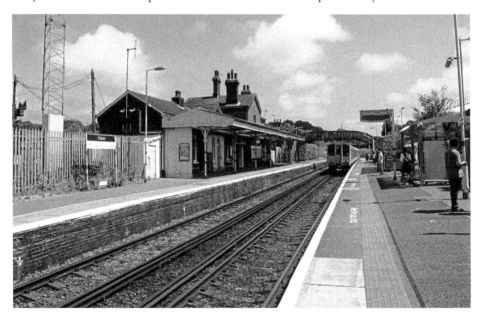

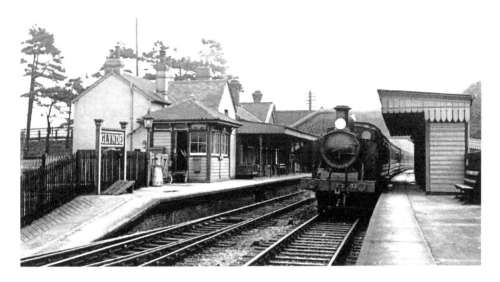

Glynde

When the railway arrived at Glynde, on today's East Coastway Line east of Lewes and west of Berwick, it was built on the then parish boundary between Glynde and Beddingham. No fewer than three industrial lines then connected to it: the Brigden chalk pit, on the side of Mount Caburn; the Balcombe chalk pit, whose siding and tunnel mouth can still be seen behind the Up platform; and a clay pit (opened in 1885), north of Glynde Reach, whose material was initially transported via a telpherage (cable-suspended buckets) system. The latter was replaced with a tramway by the late 1890s.

The line at the station was electrified in 1935.

The station building, extended in 1874, is occupied by Airworks paragliding school (and previously by a teddy bear museum!) while the house, extended in 2014, is occupied by the Sadler family. Estimated passenger usage rose from 44,734 in 2004/05 to 74,542 in 2014/15 – an increase of 66.6 per cent.

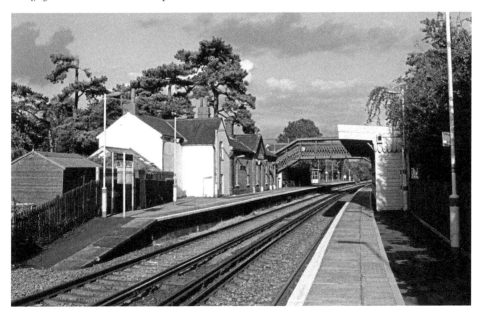

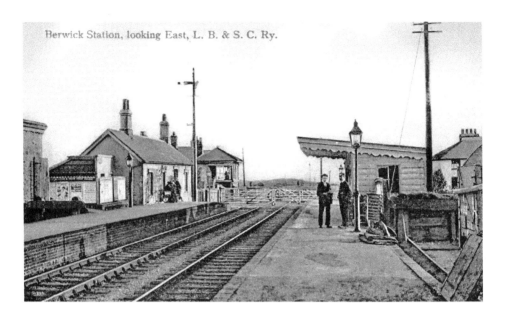

Berwick Station, looking East, L. B. & S. C. Ry.

Berwick

The postcard above, another published by A. H. Homewood, was sent to a lady in Bromley on 5 November 1906 by 'Laura', who wrote proudly, 'This is our station'. It was on the single-track Brighton Lewes & Hastings Railway's route from Brighton to St Leonards (Bulverhythe) and its opening year of 1846 was the same, of course, as Glynde's. However, unlike its neighbour, it has seen declining passenger numbers in recent times, specifically from 87,086 in 2004/05 to 77,346 in 2014/15 (-11.2 per cent). Extended in 1890, Berwick had the distinction in the 1920s of dispatching more milk churns than any other railway station in the South.

The crossing gates were replaced by barriers in 1963 and in the following year it lost, from the Down side, its only remaining siding. Its (operational) signal box, erected in 1879, was listed Grade II in 2013.

The author's photo below shows the receding 15.48 Lewes–Eastbourne through service on 19 September 2015.

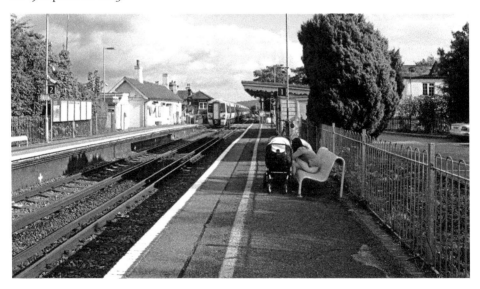

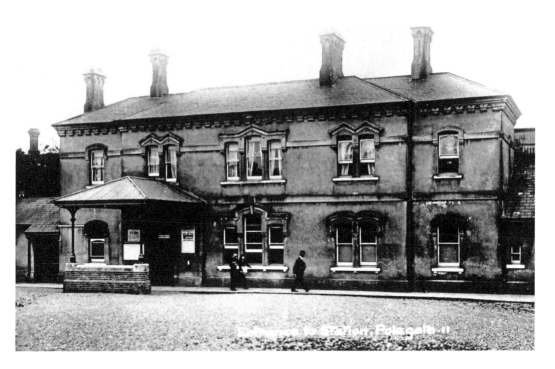

Polegate

Polegate has had no fewer than three stations. Remarkably, the third of them, opened in 1986, stands on the same site as the original one of 1846, most of whose buildings survived until the 1960s. Polegate became a junction in 1849 when joined by branches northward to Hailsham and southward to Eastbourne.

In 1881, the second station (see the 1920s photo above) opened 440 yards away to the east in connection with a new track alignment between here and Hailsham, allowing trains to travel direct to Eastbourne. Writing in 1985, the year before the station closed, railway writers Vic Mitchell and Keith Smith described it as 'one of the most dilapidated in the South'. Since then, however, a transformation has taken place. The elegantly restored building, much extended at the rear, opened as a pub/restaurant on 19 July 1988, named 'The Old Polegate Station'. It continues to prosper today as a restaurant.

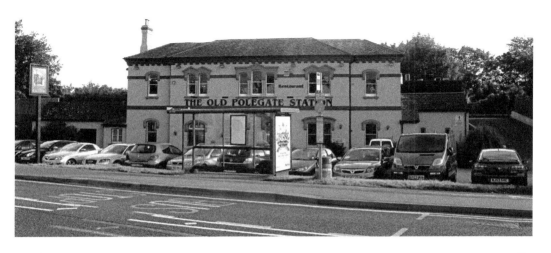

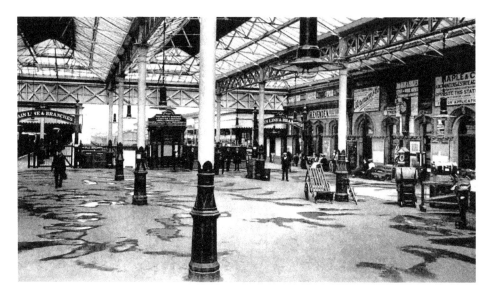

Eastbourne

Eastbourne's first rail connection, a single-track branch line from Polegate on the Brighton—Hastings line, was opened by the LBSCR on 14 May 1849. The station, a modest timber structure, was used until 1866, when it was moved to Wharf Road, where it was used as a dwelling for railway families. In that year, a new station was built nearby, followed by a third in 1886 – the present, Grade II listed one. Designed by F. D. Brick, it is dominated externally by a large pagoda-like lantern to illuminate the interior and a clock tower with a French-style pyramidal roof. The station had four platforms, which increased in length over the years. On 12 April 1977, however, Platform 4 (out of sight on the right) was shortened to make way for the ring-road construction and, in 1991, was taken out of use.

In the photo below, local school and college banners decorate the concourse on 13 January 2016.

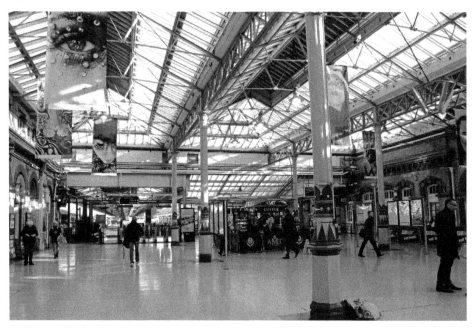

Hastings

The opening of the original station here on 13 February 1851 is memorable for all the wrong reasons. The LBSCR had the necessary powers for its operation via the absorbed Brighton, Lewes & Hastings Railway, but Parliament changed its mind and decided that the SER was better placed to operate the route. Unpleasant confrontations between the rivals erupted in the so-called 'Second Battle of Hastings'. An uneasy coexistence on shared facilities continued until the Grouping, when the Southern Railway took over. In 1931 the entire station was rebuilt in the New Classical style to the design of J. R. Scott, with a remarkably spacious, octagonal booking hall. Two island platforms were provided in the new layout, the left-hand one occupying the site of the former locomotive depot. The building, seen above in the 1970s, was, sadly, allowed to deteriorate and was demolished in 2004, to be replaced by the elegant postmodernist structure we see today.

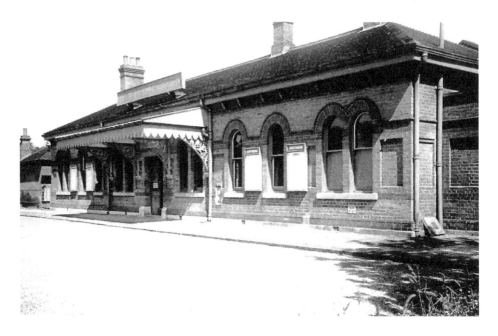

Crowhurst

Once the northern terminus of the West Bexhill branch, Crowhurst was, like the other two stations on that line (see pages 35 and 36), a latecomer to the East Sussex railway scene, being added to the London–Hastings route by the SECR in 1902, a full fifty years after that line's completion. It served as a junction, with Up and Down through platforms and a bay platform at the southern end of each (now fenced off), until 1964 when the branch closed. Although a small building on the Up side has survived, having been originally retained for use as booking office, the substantial signal box is long gone, while the main station building was, for its part, demolished in November 1984.

Estimated annual passenger usage declined from a peak of 54,031 in 2007/08 to 36,268 in 2013/14, but recovered in 2014/15 to total 43,616.

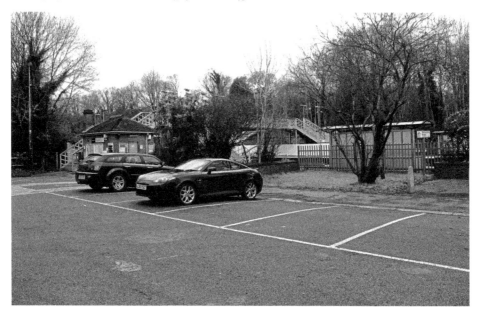

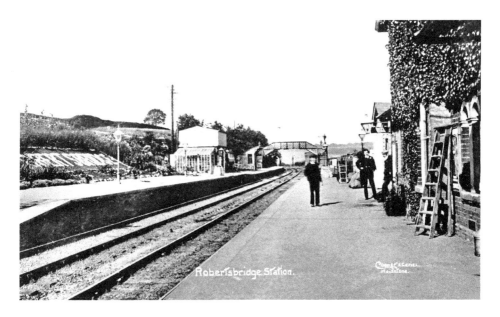

Robertsbridge

This attractive Italianate station, one of several designed for the SER by gifted architect William Tress, unusually had a glasshouse and its name spelled out in flowers on its Up platform. When opened in 1851, it was temporarily the terminus of that railway's Hastings line from Tunbridge Wells. The connection with the existing route to Hastings itself followed in 1852. In 1900, Robertsbridge became a junction with the opening of the Rother Valley Light Railway to Tenterden Town (extended to Headcorn in 1905, when the railway was renamed the Kent & East Sussex Railway). All regular passenger services were withdrawn in 1954, although freight services to Tenterden continued until 12 June 1961. The goods shed has survived as a garden machine centre.

See page 40 for the Robertsbridge-based RVR's ambition of a link to Bodiam. Below, Southeastern eight-car Class 375 Electrostar 375 627 formed the 13.27 from Cannon Street on 25 October 2015. Engineering works further south prevented onward travel.

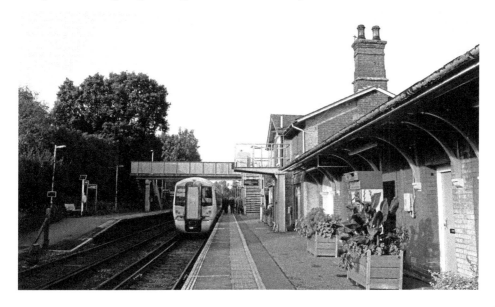

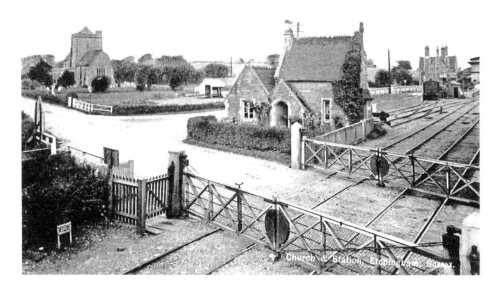

Etchingham

This charming Homewood postcard highlights the crossing gates, the elegant keeper's cottage (now lost through road-widening) and the splendid fourteenth-century church at the expense of Tress's impressive Gothic station in the background. Opened on the same day as Frant, Wadhurst, Witherenden, and Robertsbridge (1 September 1851), this was constructed on the site of an old manor house using Kentish ragstone. A large ornate canopy with a deep overhang obscures its fine lines from the opposite platform, however. While the ticket office has remained in use, the adjacent stationmaster's accommodation lay semi-derelict in recent years, but has fortunately been restored – as a bistro – following overwhelming local support in a 2007 survey for a village pub. The original pretty garden has also been brought into public use by Bistro@thestation, which opened in April 2010 and won a National Railway Heritage Award at its first attempt and two further awards in 2011.

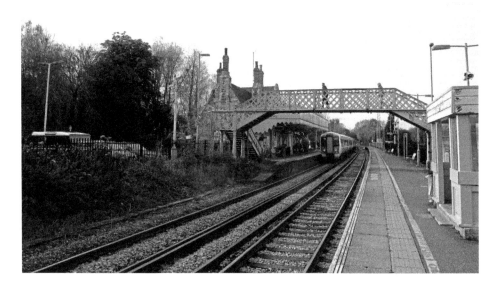

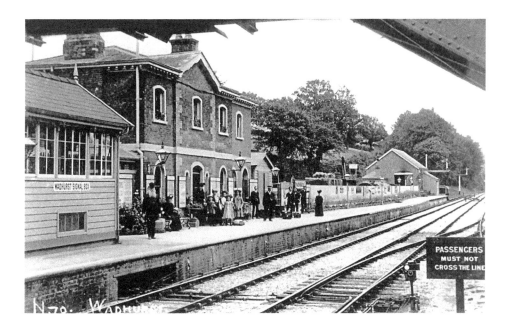

Wadhurst

It is hard to believe that this Italianate gem was proposed for closure by Dr Beeching, especially since it was the busiest intermediate station on the route, despite being over a mile away from the town. Even in this century, estimated annual passenger numbers have consistently averaged around 0.4 million. Electrification in 1986 reduced the journey time to London by 10 minutes. The car park area alongside the station fence once led to the goods shed and all that area was once given over to sidings. Most unusually, a separate coal siding diverged and ran down the slope facing the Railway Tavern, now lost and replaced by a small housing estate. The on-platform signal box was closed in 1986 and dismantled the following year. Tress's red-brick creation was at one stage extended at its southern elevation, but so sympathetically that it can scarcely be noticed.

Building and footbridge were jointly listed Grade II in 2000.

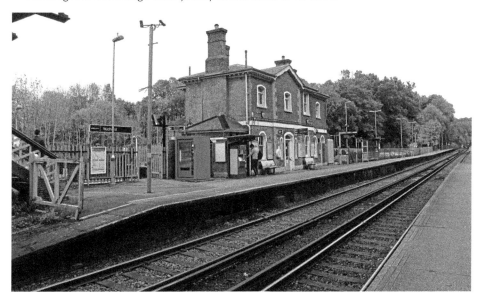

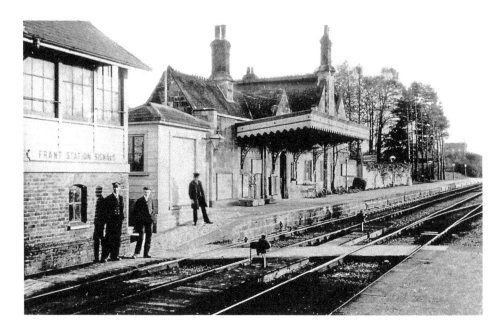

Frant

Our early view (above) must be pre-1905 since, in that year, Tress's elegant building, built of local ragstone in a Gothic-lodge style, had its canopy fitted – allegedly for the benefit of royal visitors to Lord Camden's estate. The tracery on its ironwork supports is exquisite. Other features of interest are the typical SER staggered platforms, the board crossing, the track in the foreground veering off to the goods shed and to the siding of the Ferndel Fencing Company, and the substantial signal box of 1893 (prior to this, a single post with two arms did service). The front wall of its machine room was removed to improve visibility and clearance following the death of a signalman in 1935. The station serves the surrounding settlement of Bells Yew Green, whose name the railway has added, hyphenated, to its platform signs for Frant, which is well over a mile away.

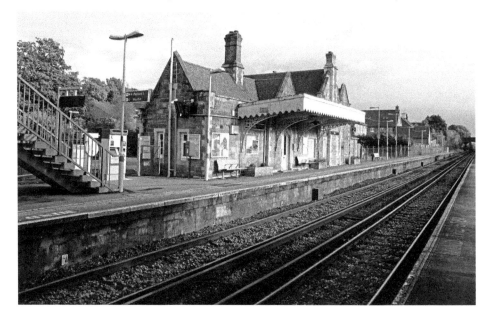

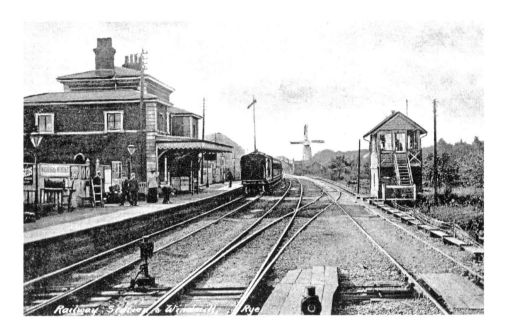

Rye

We end our journey at the distinctive Italianate station of Rye. Deemed relatively obscure, it only narrowly survived the axe in the 1960s, incredibly remaining gas-lit well into the 1970s due to the continued impending threat of closure. Yet it has emerged as one of the main stops on the important Hastings–Ashford (Marshlink) line. The early postcard shows the 1851 station building in unextended form (the extension has since 2008 been occupied by the Café des Fleurs, an unusual combination of coffee shop/florist) and the now Grade II listed, but run down, Saxby & Farmer Type 12 signal box of 1894. The distant granary is today home to the Granary Club upstairs and a disco club downstairs, while the eighteenth-century windmill has been a B&B guesthouse since 1984.

Apart from the Uckfield branch of the Oxted Line, this is the only unelectrified line in South East England. Both use Class 171 Turbostar DMUs.

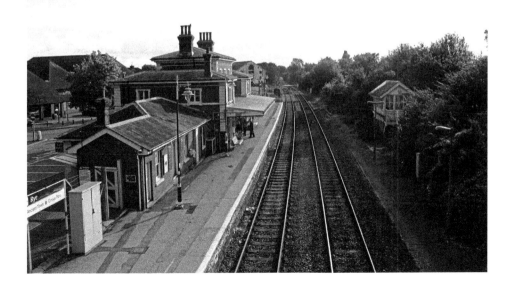

Select Bibliography

Conolly, W. P. (Ed.), *British Railways Pre-Grouping Atlas & Gazetteer*, New 6th edn (Hersham, 2015).

Barnes, P., *The Steyning Line Rail Tour – Brighton to Horsham* (Brighton, 2001).

Bathurst D., *Walking the Disused Railways of Sussex* (Seaford, 2004).

Burges, A., *Route and Branch in Sussex* (Newtownards, 2008).

Clark, P., *The Railways of Devil's Dyke* (Sheffield, 1976).

Elliott, A. C., *The Cuckoo Line* (Didcot, 1988).

Gough, T., *British Railways Past and Present – SUSSEX* (Peterborough, 2004).

Gough, T., *British Railways Past and Present – Surrey and West Sussex* (Peterborough, 1993).

Gough, T., *The Kent and East Sussex Railway – A Past and Present Companion* (Peterborough, 1998).

Gough, T., *West Sussex Past and Present – Rediscovering Railways* (Peterborough, 2002).

Gray, A., *The Railways of Mid-Sussex* (Blandford, 1975).

Gray, A., *The London to Brighton Line* (Blandford, 1977).

Grayer, J., *Impermanent Ways – The Closed Lines of Britain, Vol. 2 – Sussex*, (Southampton, 2011).

Harding, P. A., *The Rye & Camber Tramway* (Woking, 1985).

Harding, P. A., *The Kemp Town Branch Line* (Woking, 1999).

Hay, P., *Steaming Through East Sussex* (Midhurst, 1985).

Hendry, R., *British Railway Station Architecture* (Hersham, 2007).

Hoare, J., *Sussex Railway Architecture* (Hassocks, 1979).

Hobbs, R., *Steam around Surrey and Sussex* (Hersham, 2008).

Jeffs, S., *The London to Brighton Line* (Stroud, 2013).

Jeffs, S., *The Brighton Line: A Traction History* (Stroud, 2013).

Leslie, K. C., *An Historical Atlas of Sussex* (Chichester, 2010).

Marshall, L., *O. J. Morris's Southern Railways 1919–1959* (Midhurst, 1997).

Marx, K., *An Illustrated History of the Lewes & East Grinstead Railway* (Poole, 2000).

Marx, K., *London Brighton & South Coast Railway Album* (Shepperton, 1982).

Marx, K., *The London Brighton & South Coast Railway – The Bennett Collection* (Lydney, 2011).

Marx, K., *Steam in the Sussex Landscape* (Cheltenham, 1990).

Morrison, B. & Beer, B., – *British Railways Past and Present – Kent and East Sussex* (Peterborough, 1994).

Oppitz, L., *Lost Railways of Sussex* (Newbury, 2001).

Panter, M., *Lost Railways of East Sussex* (Catrine, 2013).

Panter, M., *Lost Railways of West Sussex* (Catrine, 2013).

Pryer, G. A. & Bowring, G. J., *An Historical Survey of Selected Southern Stations*, Volume 1 (Poole, 1980).

Robertson, K., *East Sussex Railways – In Old Postcards* (Gillingham, 1987).

Robertson, K., *London Brighton & South Coast Miscellany* (Hersham, 2004).

Spence, J., *Victorian and Edwardian Railways from Old Photographs* (London, 1975).

Staines, D., *A Day Out with the Spa Valley Railway* (Tunbridge Wells).

Vaughan, J., *Branches & Byways – Sussex and Hampshire* (Hersham, 2004).

Welbourn, N., *Lost Lines Southern* (Shepperton, 1996).

Welch, M., *Rails to Sheffield Park* (Weymouth, 1988).

Welch, M., *Sussex Steam – Scenes from the Fifties and Sixties* (St Leonards on Sea, 1998).

Welch, M., *Sussex Steam* (St Leonards on Sea, 2015).

Wikeley, N. & Middleton, J., *RAILWAY STATIONS – Southern Region* (Seaton, 1971).

Young, J., *Sussex Railway Stations on Old Picture Postcards* (Nottingham, 2010).

Also useful were the following books by V. Mitchell and K. Smith, all published in Midhurst:

Branch Lines to Midhurst (1981); *Branch Lines to Horsham* (1982); *South Coast Railways – Brighton to Worthing* (1983); *Branch Line to Selsey* (1983); *South Coast Railways – Worthing to Chichester* (1983); *Branch Lines to East Grinstead* (1984); *Brighton to Eastbourne* (1985); *Branch Line to Tenterden* (1985); *Crawley to Littlehampton* (1986); *South Coast Railways – Eastbourne to Hastings* (1986); *Haywards Heath to Seaford* (1986); *Three Bridges to Brighton* (1986); *Branch Lines to Tunbridge Wells* (1986); *Branch Lines around Midhurst* (1987); *Tonbridge to Hastings* (1987); *Sussex Narrow Gauge* (2001).

Online sources: Newsletter Archive of Sussex Industrial Archaeology Society (various issues/ authors); Wikipedia; Office of Rail and Road: Estimates of station usage; and many other sites.

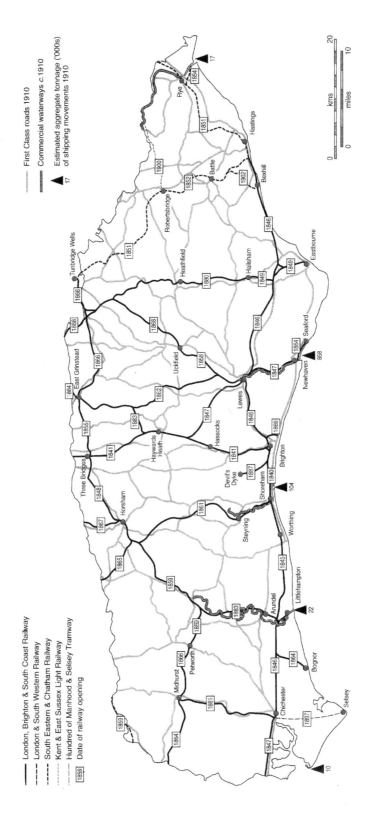

Legend:

London, Brighton & South Coast Railway
London & South Western Railway
South Eastern & Chatham Railway
Kent & East Sussex Light Railway
Hundred of Manhood & Selsey Tramway
1859 Date of railway opening

First Class roads 1910
Commercial waterways c.1910
Estimated aggregate tonnage ('000s) of shipping movements 1910
17

Historical map of the railway network in Sussex by company and dates of line openings.